Atlantis Risen,
UFOs and Orbs

Elizabeth Eagle

ISBN 9781492130802

Atlantis Risen

While living in Sedona I discovered evidence of an ancient civilization. I noticed many anomalies that defy explanation and photographed them while hiking among the red rocks. I will include some of the best photographic evidence here so that you can draw your own conclusions. I have literally hundreds of pictures I could share.

It is my opinion that these formations were created long ago because of the erosion that has obviously taken place. I believe an advanced intelligence put the rocks together or worked in cooperation with nature to 'grow' the formations. Our scientists today can grow crystals in a lab so I don't think it's that far-fetched to believe that a highly advanced civilization occupying Earth very long ago was able to create fabulous structures perhaps using similar technology.

I've found evidence of the same civilization covering the four corners region of the United States. From the top of Pikes Peak to the Garden of the Gods in Colorado to Lake Powell and Moab in Utah similar construction exists. I've seen similar structures in documentaries about Peru, China, and Mexico among other distant locations. Perhaps the ancient civilization I refer to crossed the globe at one time in our very distant past.

Was this Atlantis? Was this part of an an ancient civilization we have yet to consider?

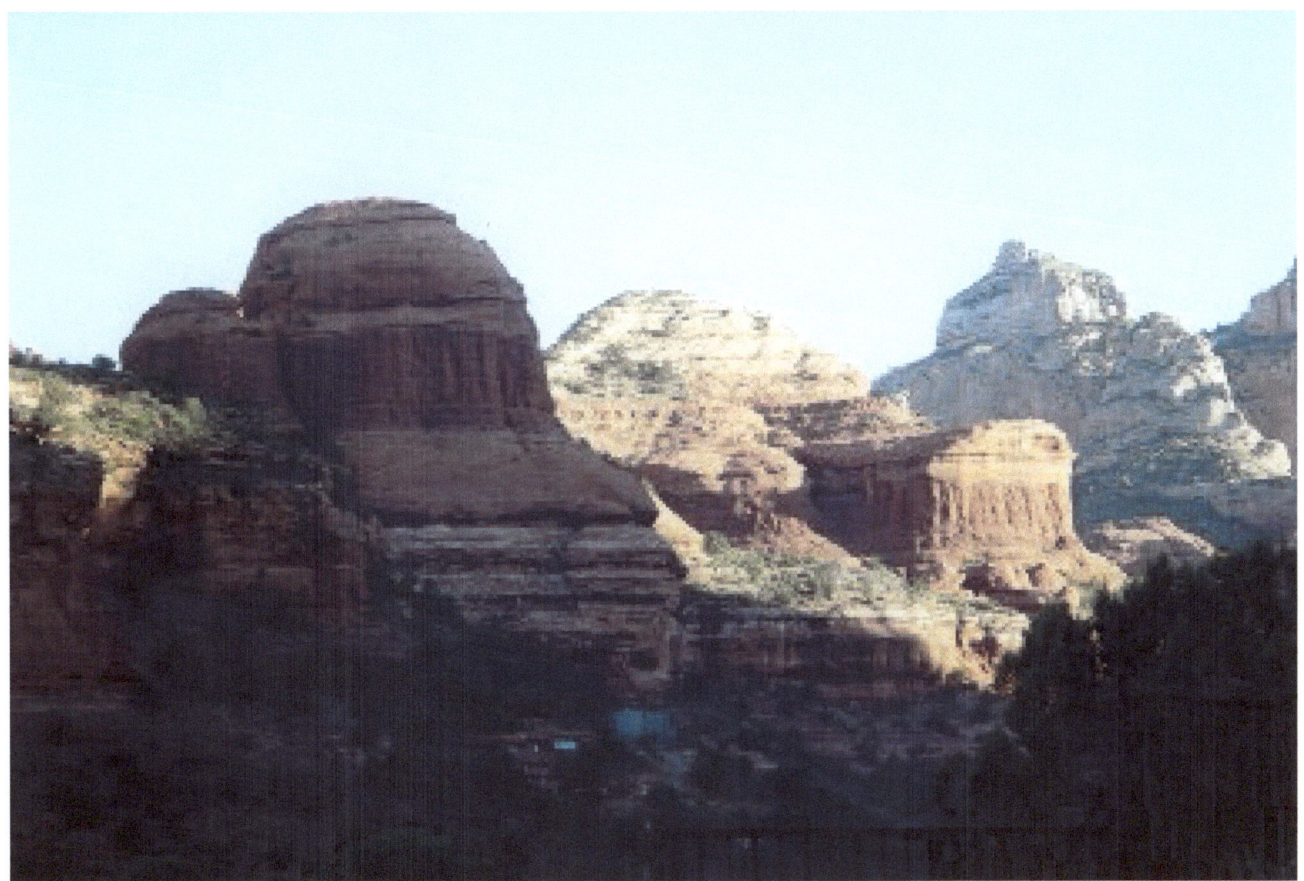

This picture was taken by the Enchantment Resort in Arizona near Sedona. The domed structure on the left could have been the inspiration for many of our famous buildings today, including the US capital building in Washington, DC. Was the structure with the columns (in the sun) used as a model for the Parthenon in Greece? Could step-pyramids in Egypt and Mexico have been based on the rock formation on the right side of the picture? I believe so. Who or what was behind their magnificent design?

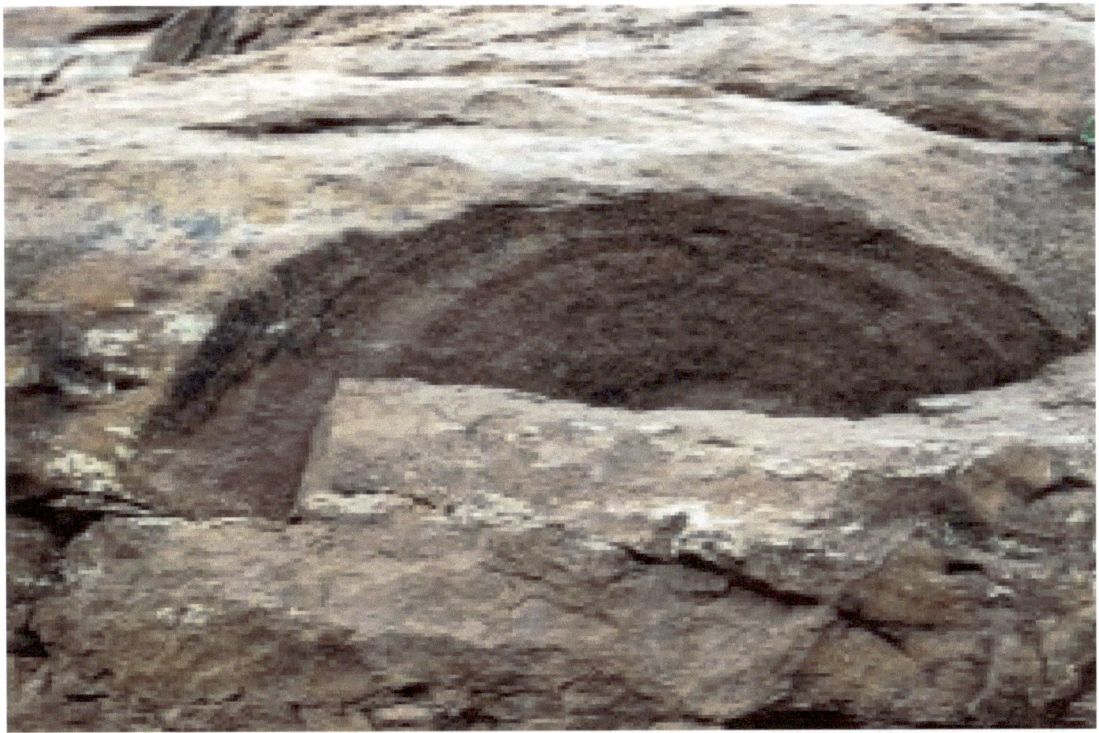

What could have caused these radial marks on this rock? Was "other worldly technology involved? Were lasers used?

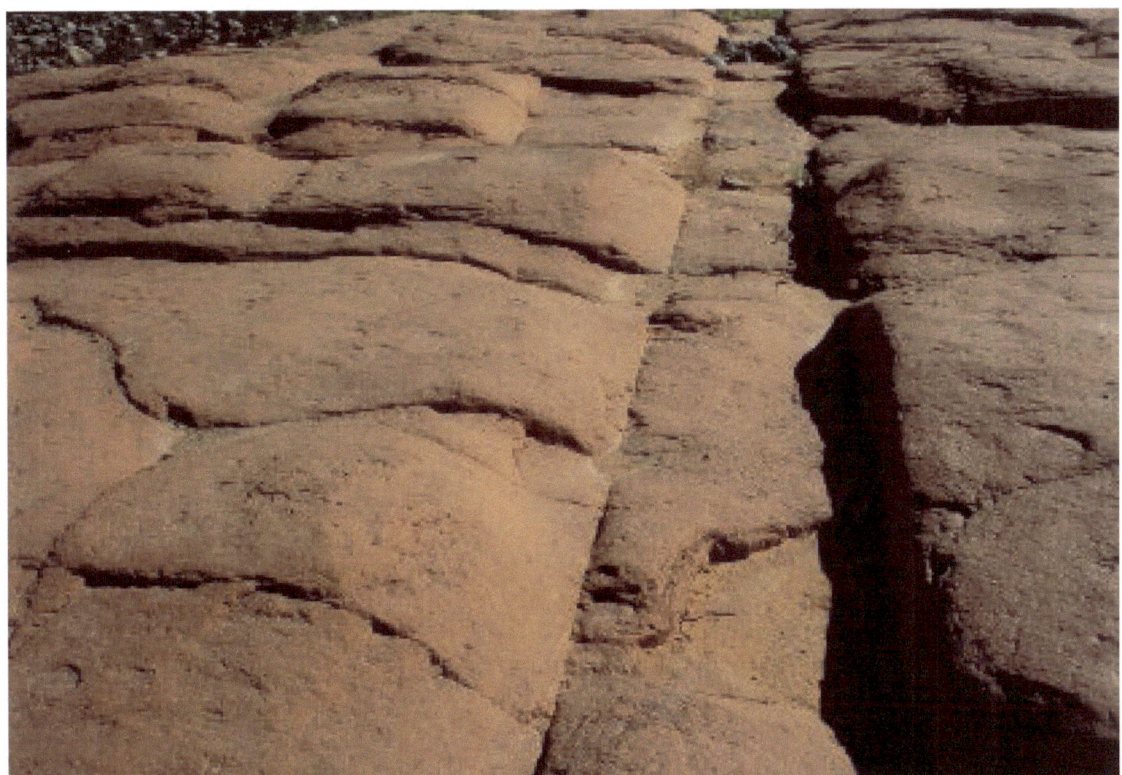

Erosion reveals planned "channels" in these rock formations. Notice the curves incorporated and the precision used to place (or grow) these stones together. Could they have been formed using some kind of cosmic concrete? How long ago were these perfectly spaced lines engineered?

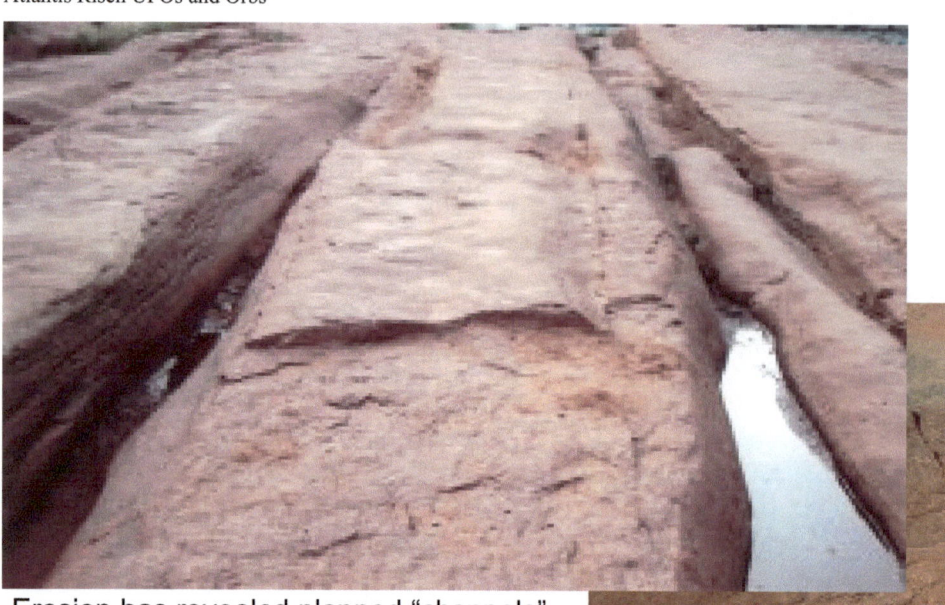

Erosion has revealed planned "channels" in these rock formations. Erosion takes time, which means this construction must be beyond ancient. How often have these lines been under the ocean?

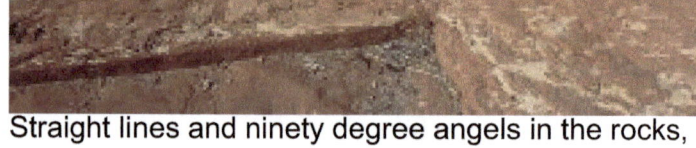

Straight lines and ninety degree angels in the rocks, shown here, do not appear natural.

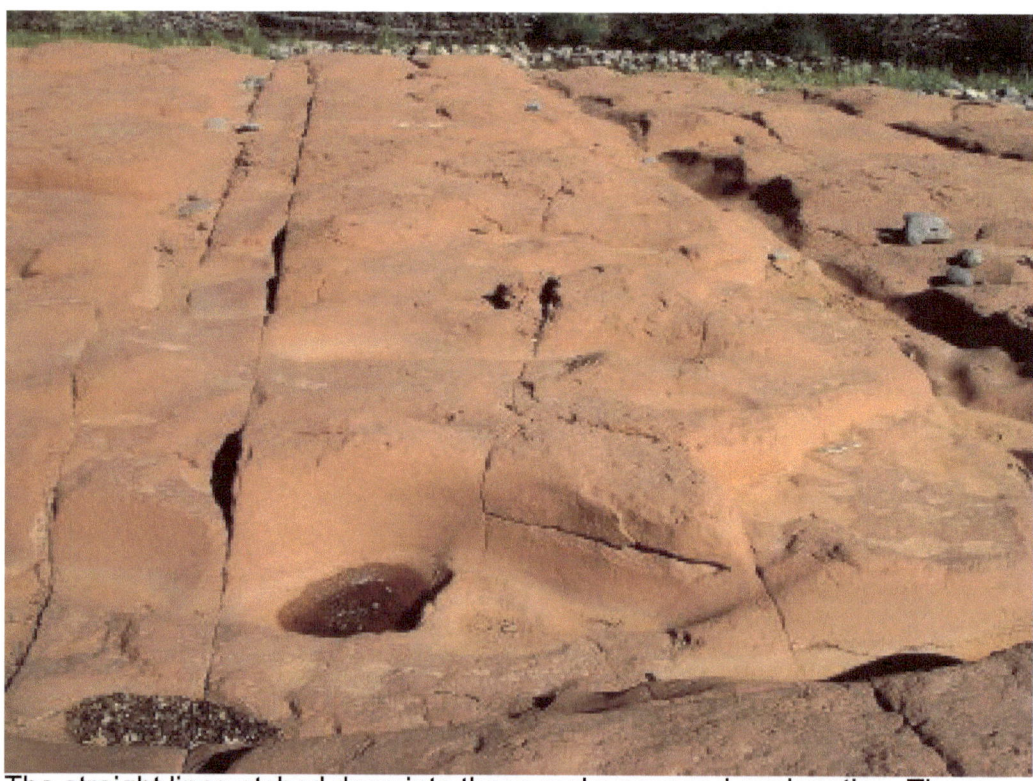

The straight lines etched deep into these rocks escaped explanation. These lines don't appear random and over time erosion has caused them to become more obvious. How and when were they formed? This is no "accident."

Uneven Erosion – When stones form close together their erosion "should be" similar. The multi-layered rock on top of and beside the more solid rocks makes no sense. The ninety degree angle at the base of the platform that the multi-layered rock sits on is interesting, and so are the perfectly perpendicular lines in the foreground of this picture. What could explain this?

What caused this zig-zag line cut in stone beside the perfectly straight line in this picture? There is no logical explanation for this except that intelligence must have been involved in its construction long ago.

Was this some sort of rock "patch work" quilt created using cosmic concrete? The precision placement of these rocks and the curves involved were unlike anything I'd seen before. I wish I knew how this was created, who created it, and why.

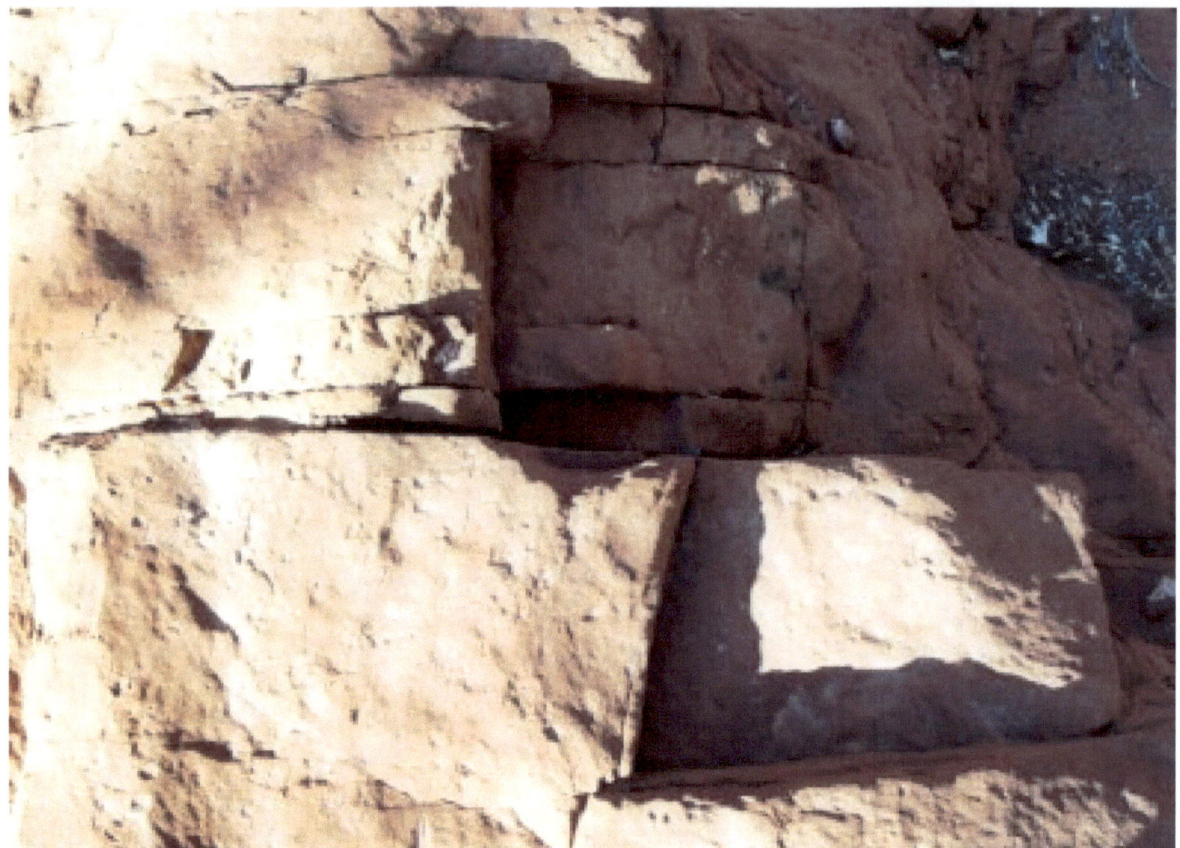
Intricate detail illustrating a "jig-saw puzzle" from the gods?" It appears these rocks were placed together with intention. For what purpose? By whom?

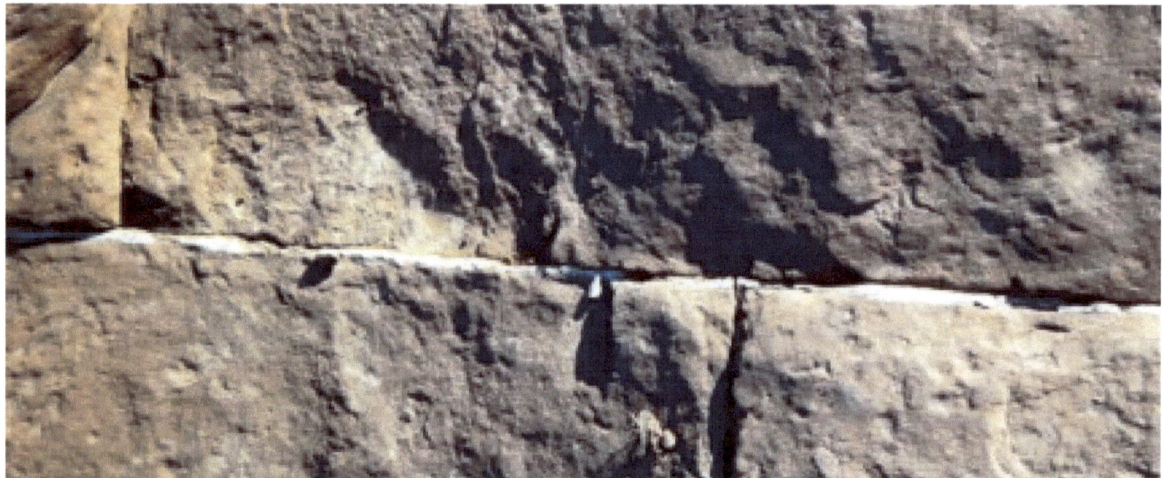
Is this a picture of crystalline mortar between these rocks? Some day I'd love to "date" both the rocks and their mortar and see if they are from the same time period. This might not be possible because my theory is that these were placed together millennium ago. There may be a limit as to how far back science can date things such as these.

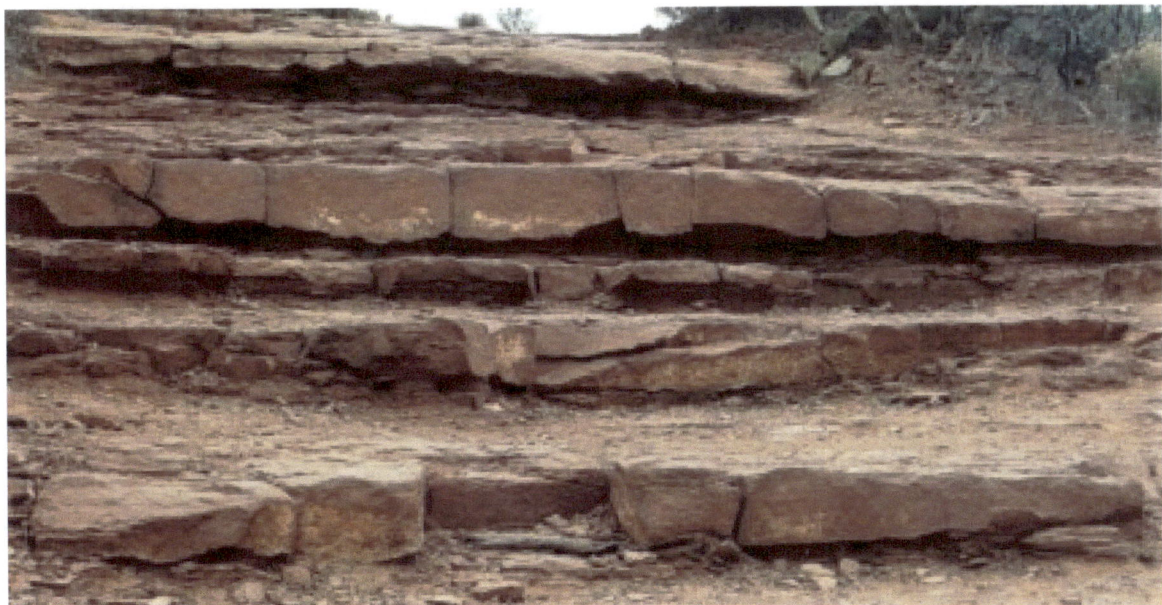
These rocks appear to have been intentionally placed together. I wonder why. Were they part of a staircase? Where did it lead? Up the mesa to a landing site? I wonder.

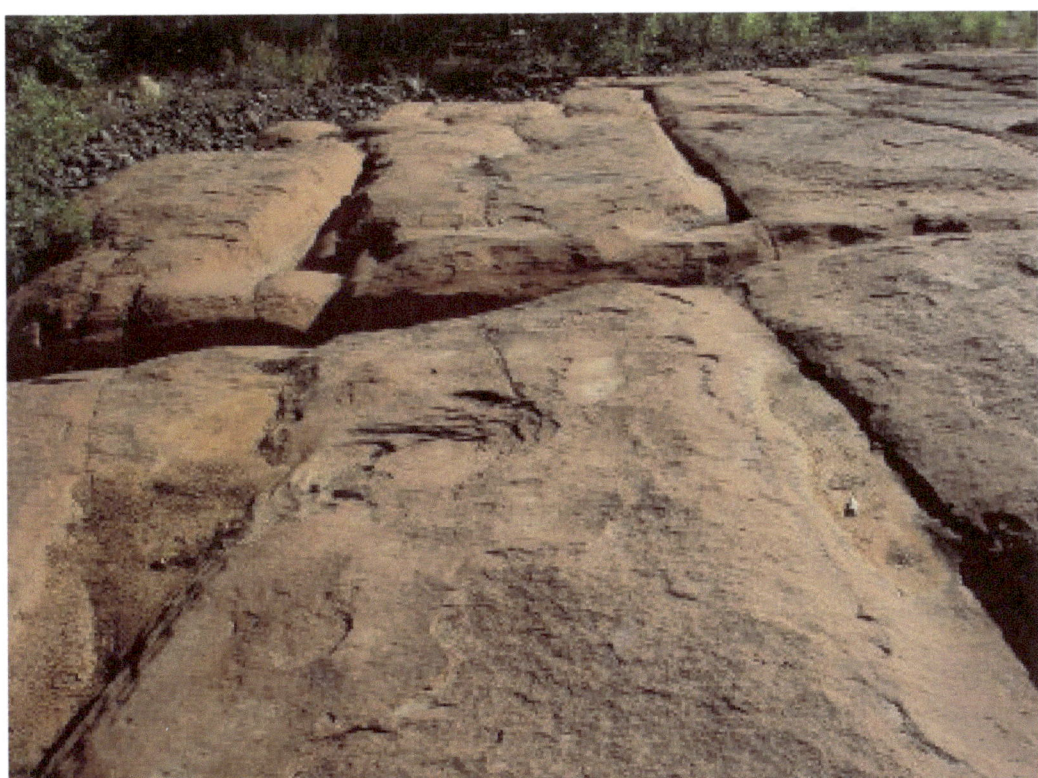
Erosion proves these rectangle formations are ancient. Who could have created them? How? What do they mean? These incredible lines are located near Sedona, Arizona.

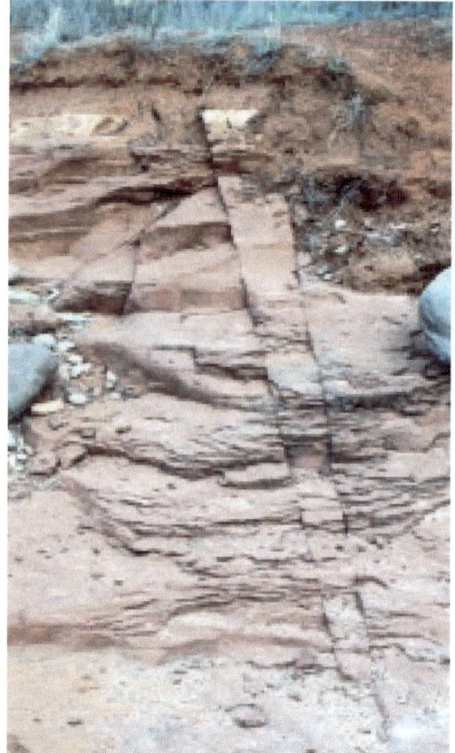
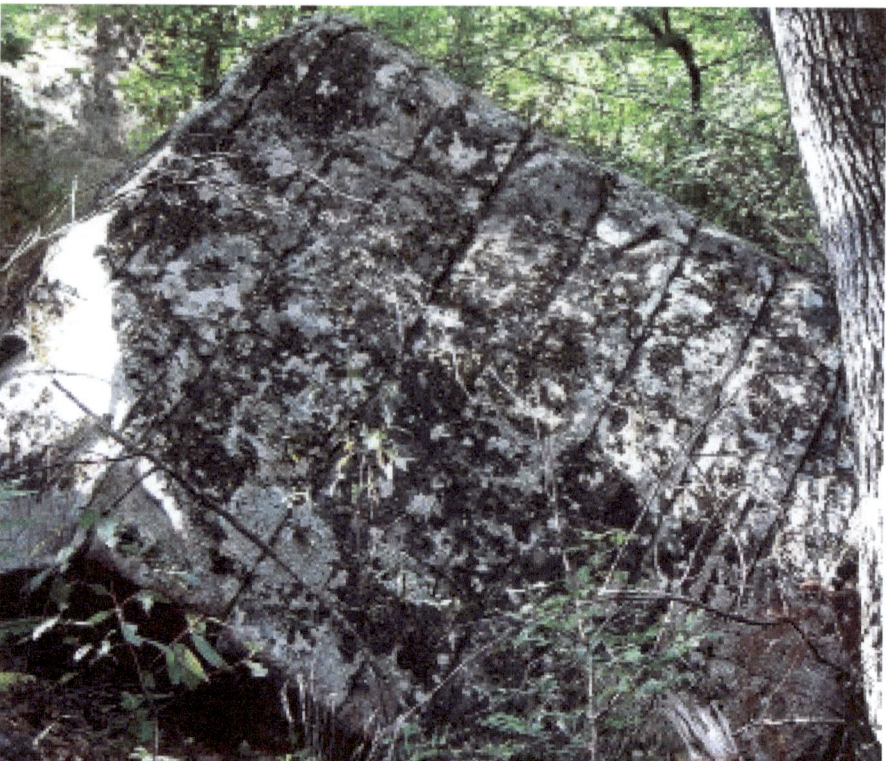

These diagonal lines don't appear random. How and when were these lines formed? Is there a natural explanation?

Nature doesn't make huge rocks with perfectly parallel lines. I found this obviously engineered specimen in Arizona. I believe it was created by an intelligence we have yet to understand. The equally spaced parallel lines suggest creative intelligence was involved in its formation. What was this huge stone used for?

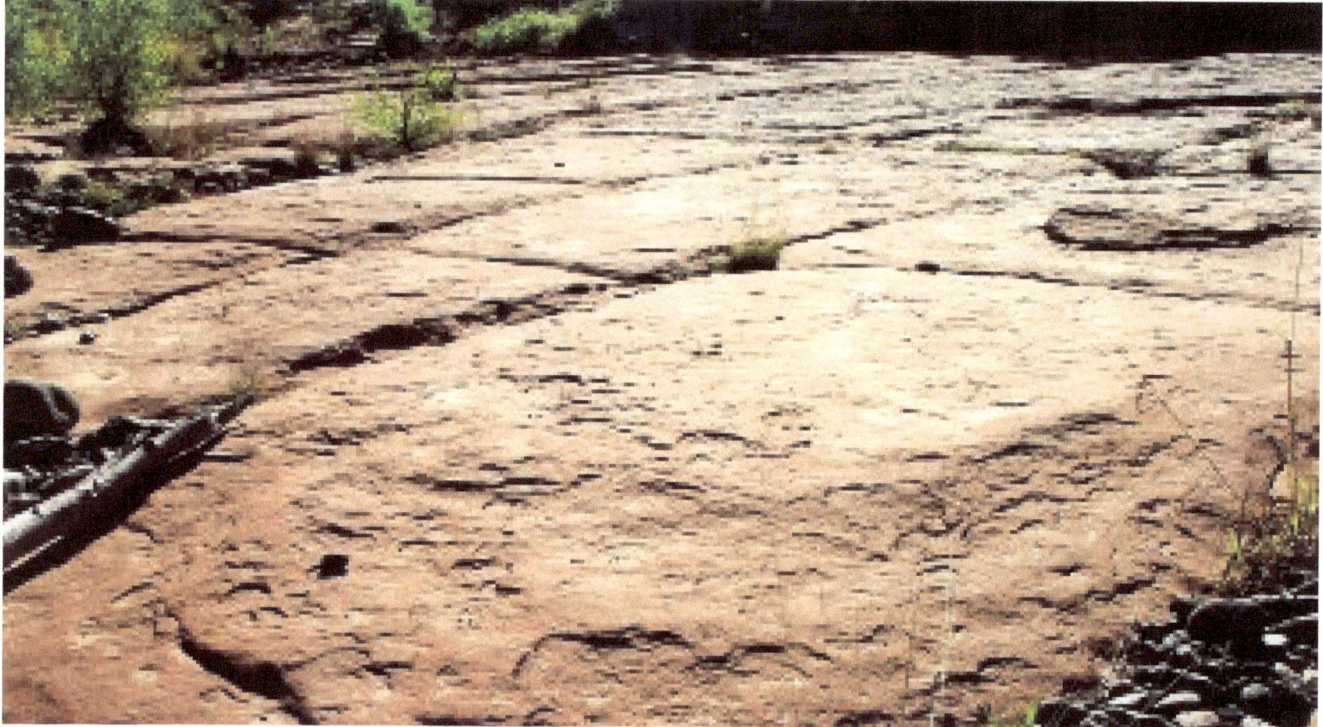

These huge rectangular rock formations remind me of small garden plots. This area has been above and below the ocean multiple times yet its rectangular perfection remains. It was built to last.

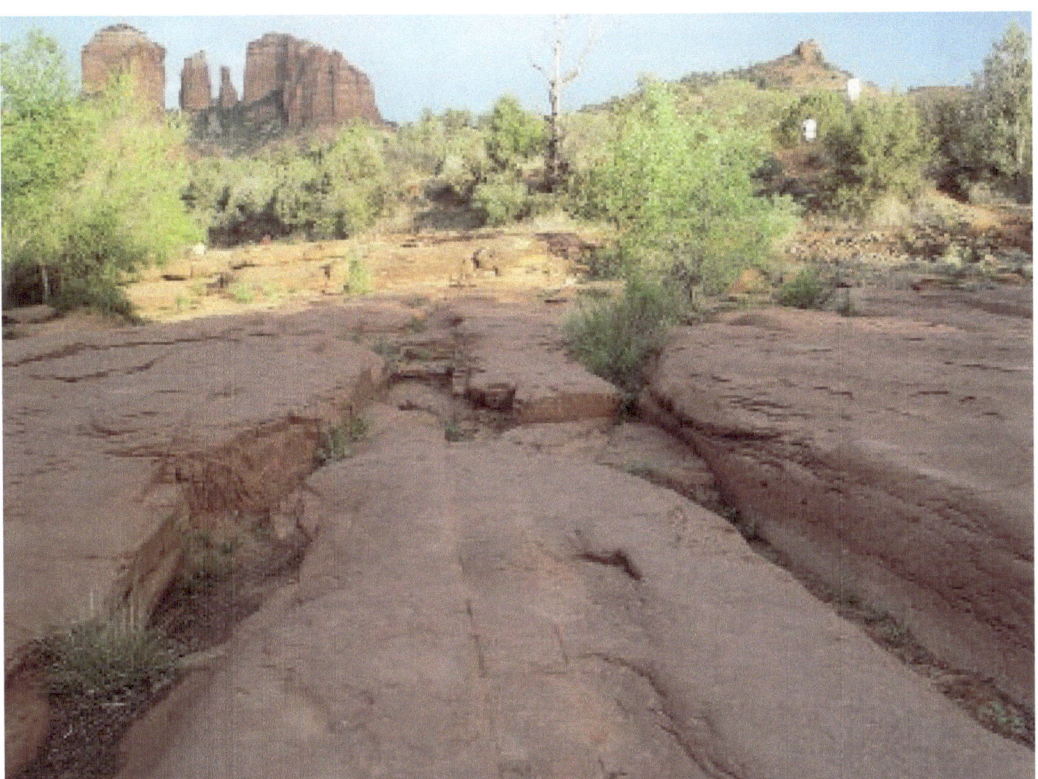

Why was this area "paved" with red rock? Where the towers of Cathedral Rock (in the background) part of a communication grid for this ancient civilization? Anything is possible.

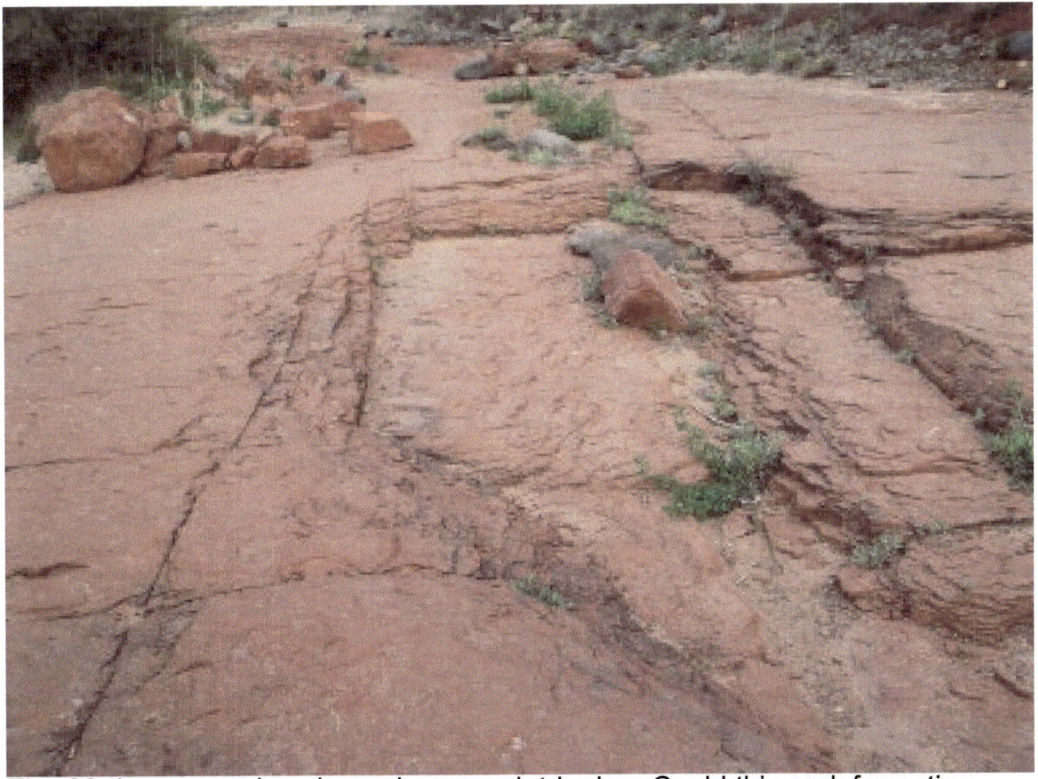

The 90 degree angles shown here are intriguing. Could this rock formation have been constructed as a pool or for water storage? We can only imagine.

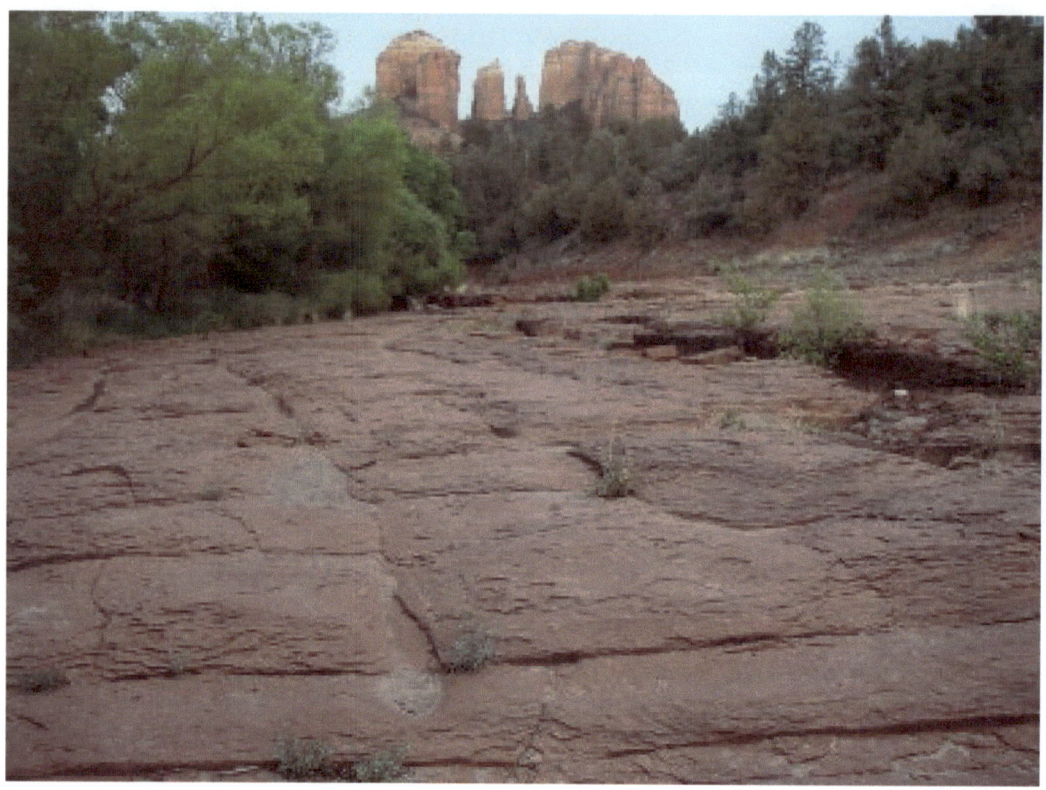

Nature doesn't normally build fields of rectangles like the amazing ancient construction shown here.

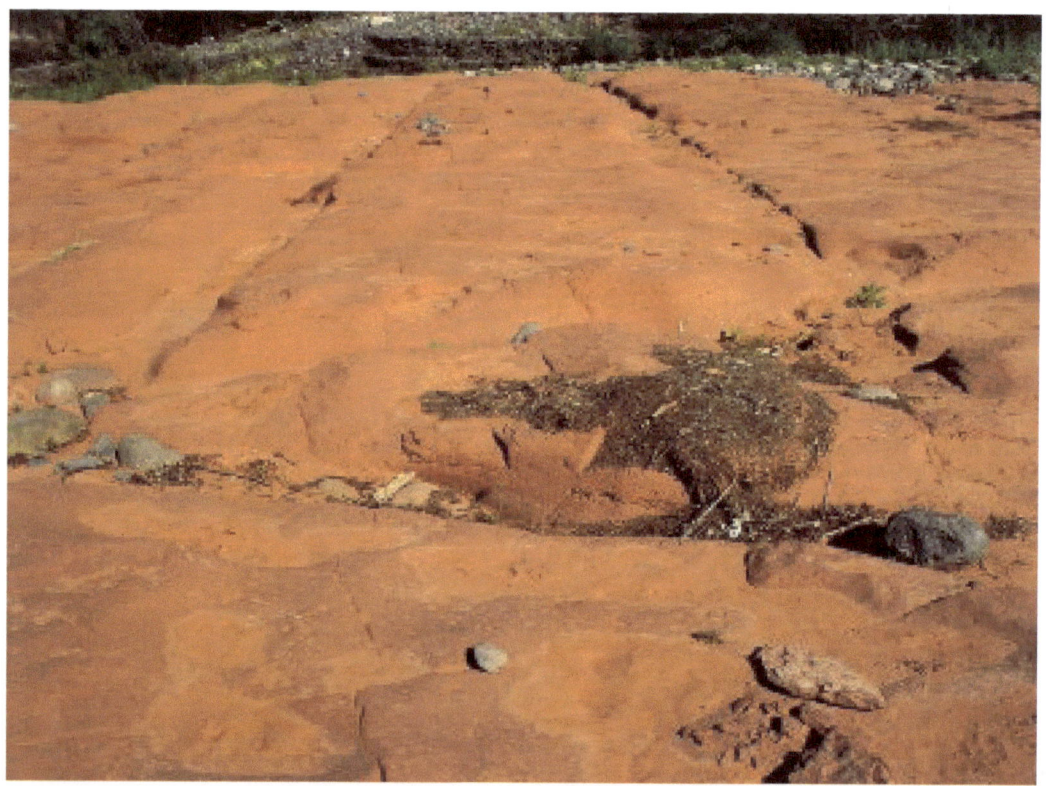

What might explanation these perfectly straight parallel lines near Sedona, Arizona? Nature doesn't normally build with perfectly straight lines.

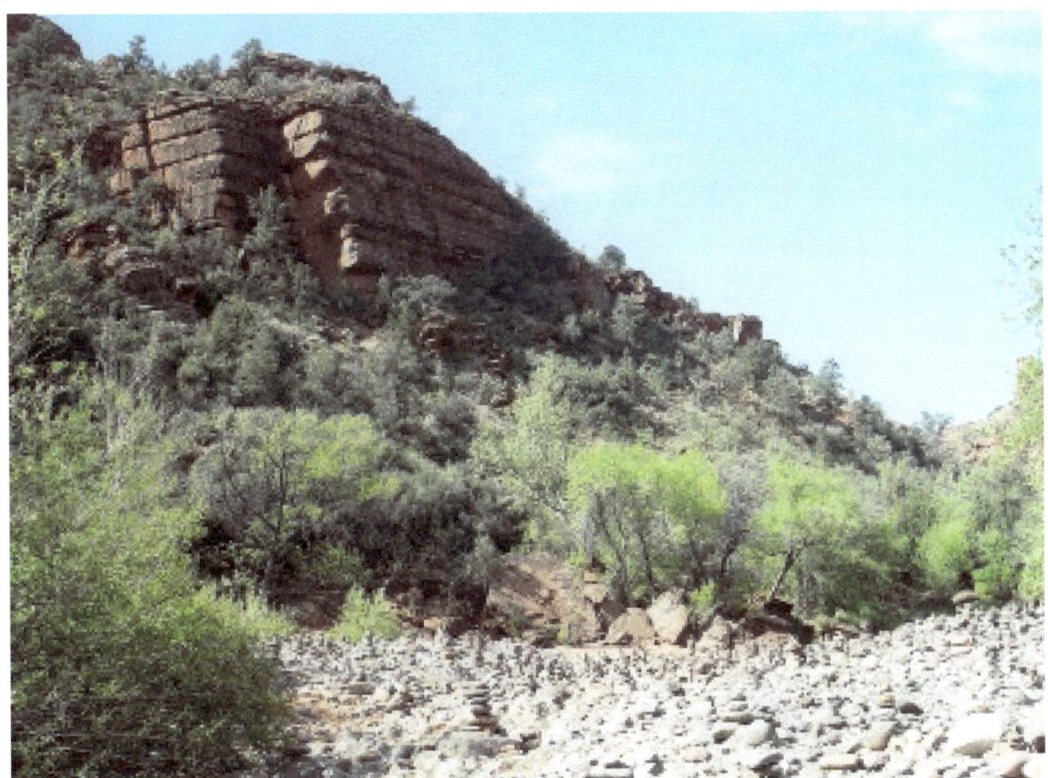
This area at the base of Cathedral Rock is known as Buddha Beach. The pyramid structure inspires rock stacking here. Was this structure engineered?

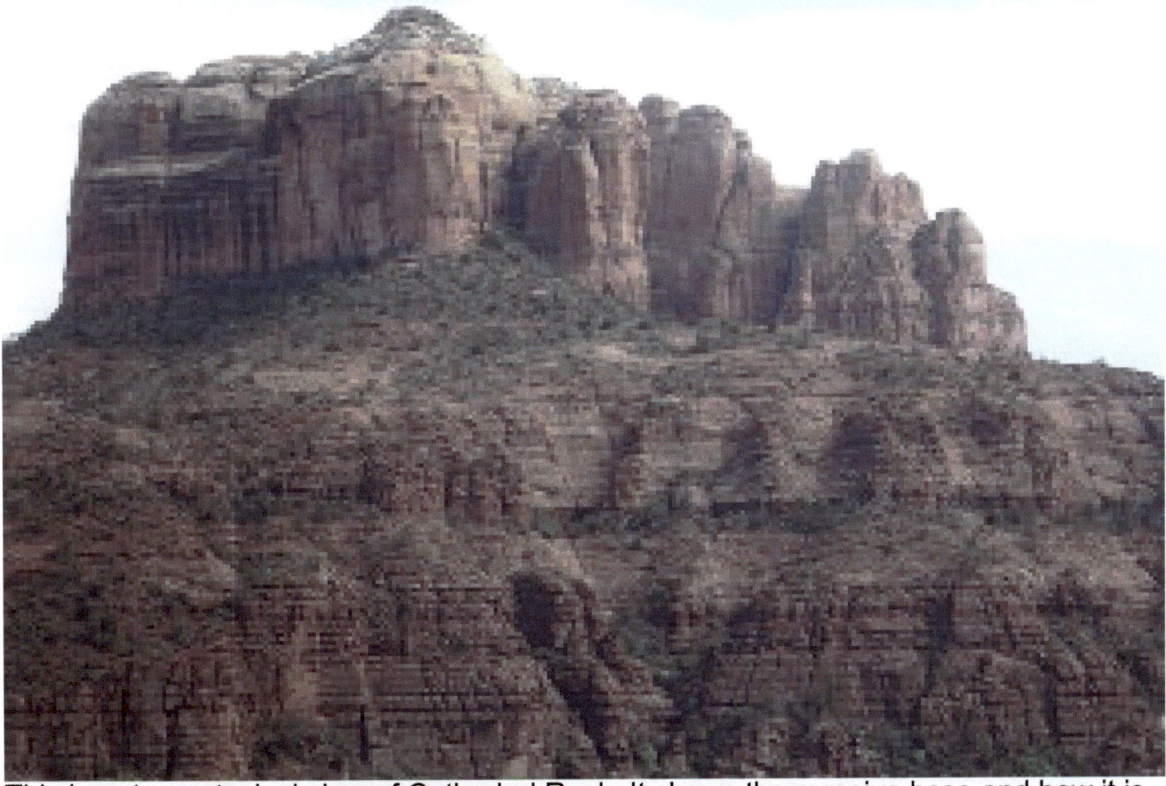
This is not your typical view of Cathedral Rock. It shows the massive base and how it is constructed using horizontal lines and verticle layers. Is this some sort of communication tower set in stone? Is it still generating signals today? Is it hollow? Are there caves or tunnels inside? If so, what might they reveal?

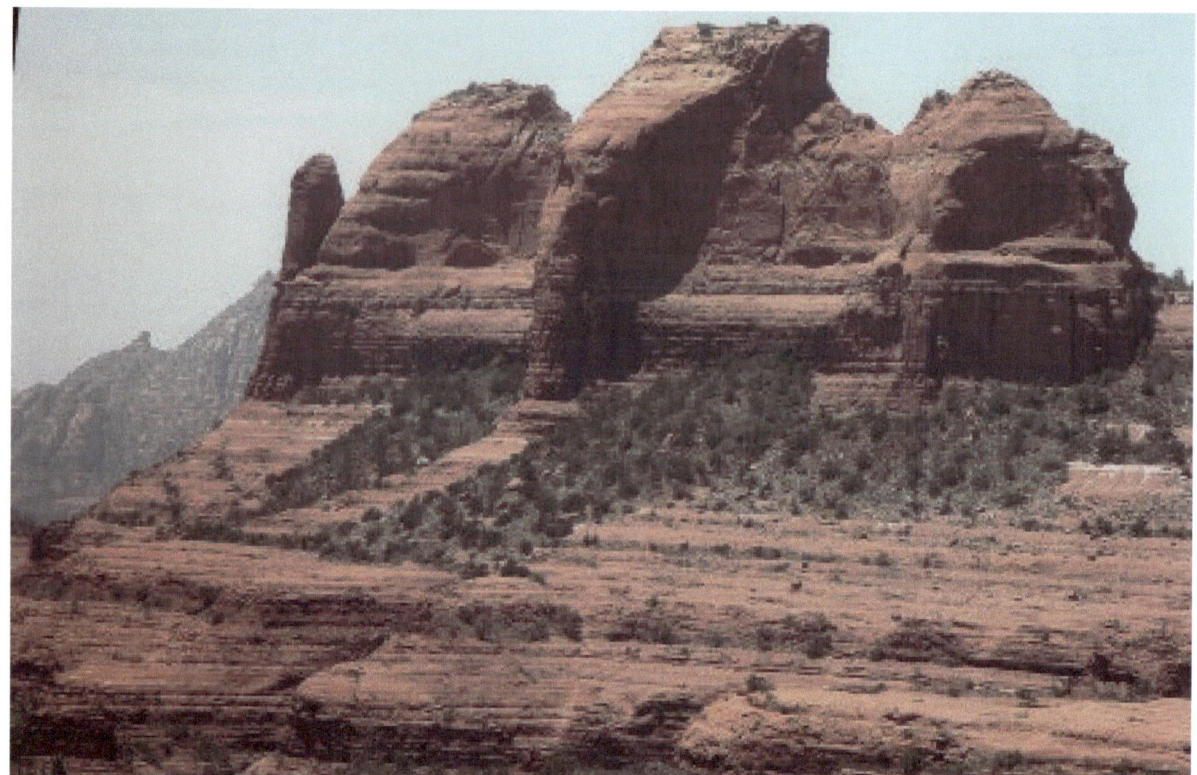

This formation near Sedona, AZ reminds me of the Sphinx near Giza, Egypt. The Center rock resembles the head of a king with a beard and head dress. Perhaps the same civilization that built the base of the sphinx built these structures as well.

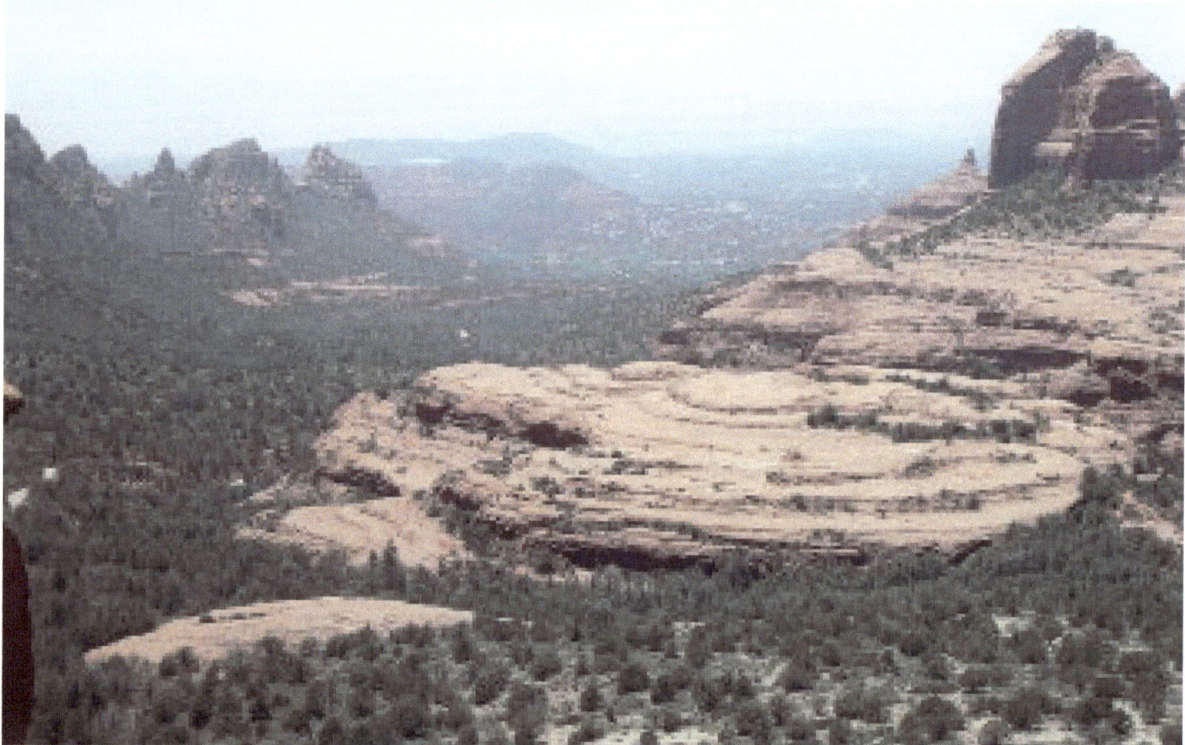

Here's a view of what I believe is an ancient landing sight for interstellar vehicles. Who is to say what this formation was used for, but it does beg the question. Could this have been a landing sight for ships from other worlds? Is it still in operation today? Notice the profile of the head of the king in the upper right hand corner of the picture.

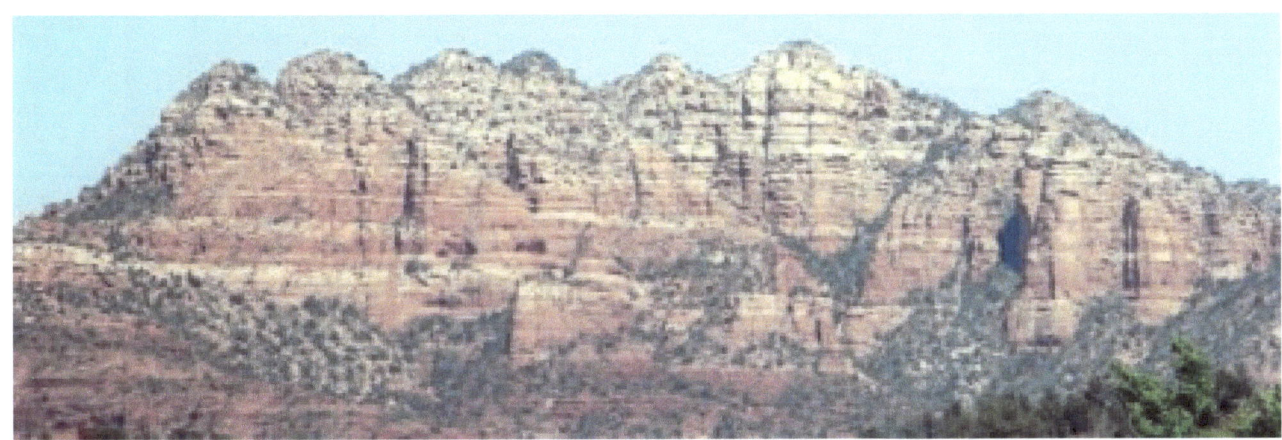

On a grand scale, these "mountains" near Sedona, with their near perfect angles, do not appear random or natural. Who or what put them together and why?

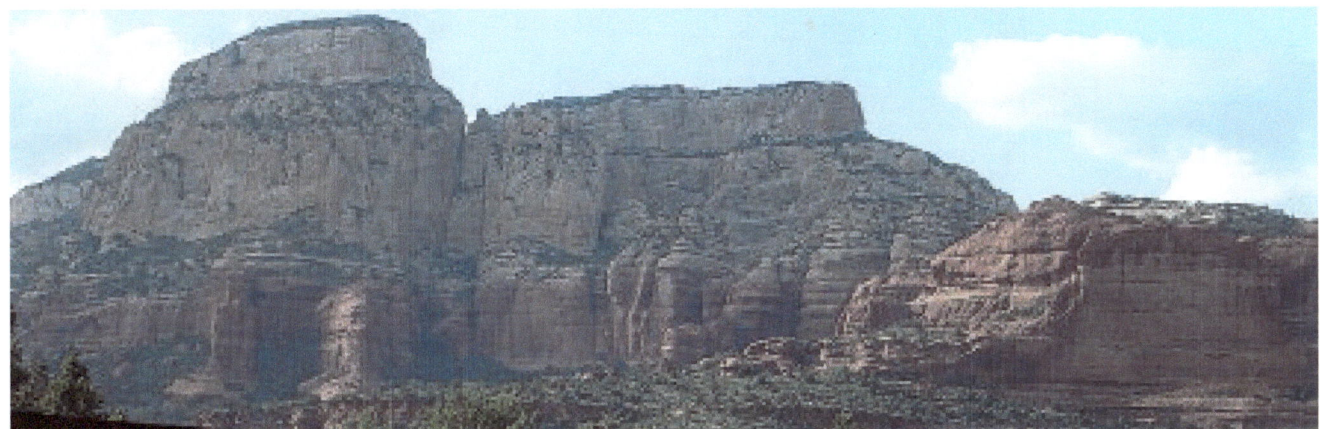

I call this temple structure rock formation "Entrance to the Valley of the Kings." It appears far to perfectly constructed to be just an accidental rock formation near Sedona, Arizona.

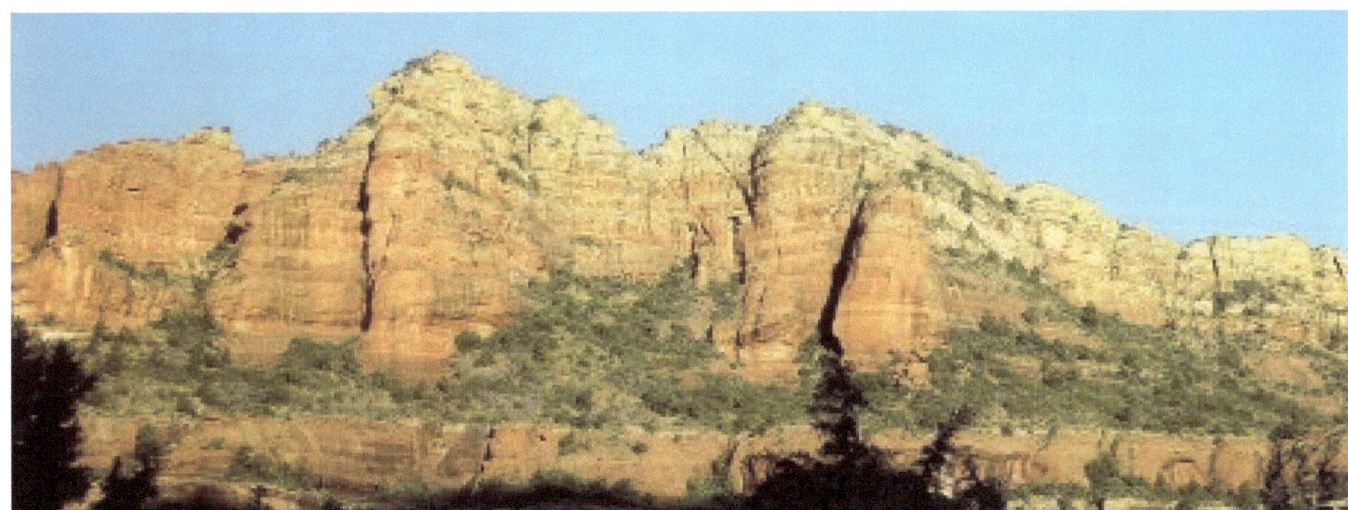

This sand castle rock formation simply amazes me because of it's parallel horizontal lines. What does it mean and what could possibly have caused its formation? I believe there was intelligence behind it's construction. I wonder what is inside it.

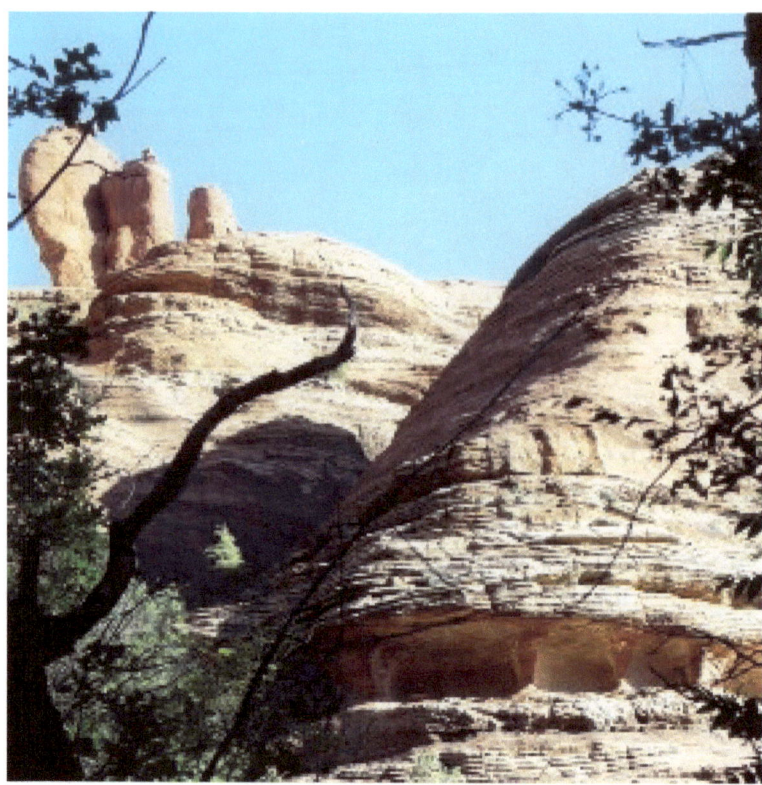

This picture is very strange to me. What could have caused the stall like indentions that look like shallow caves, or the antenna looking spire rocks shown here?

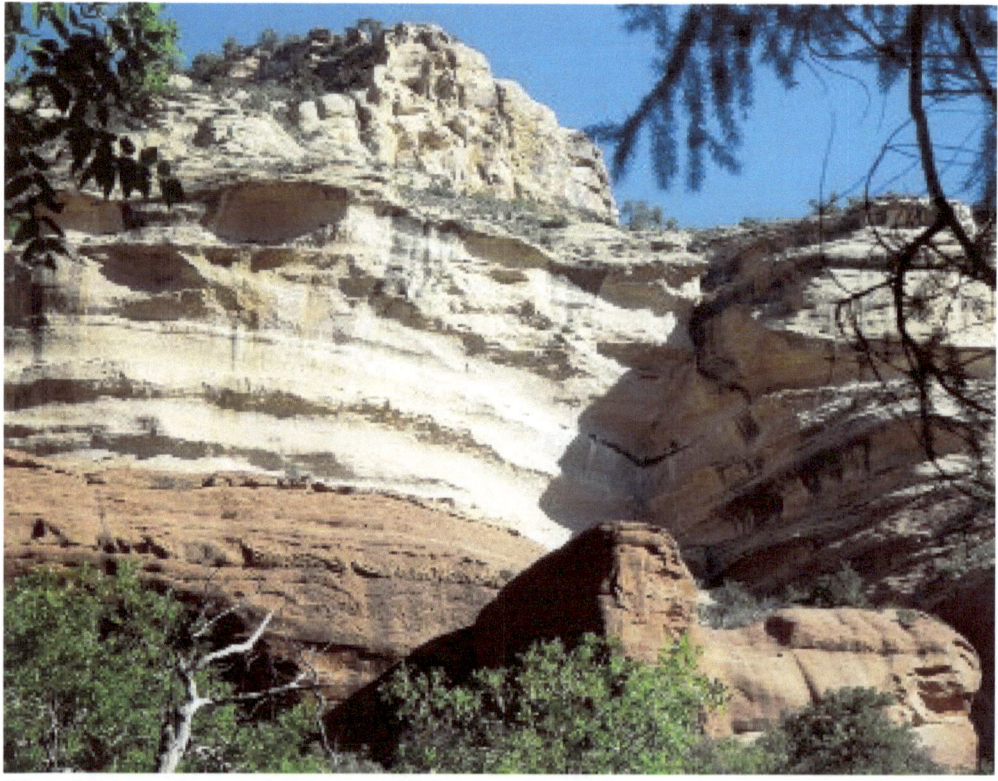

The right angles and curves of this rock formation makes one wonder if it were built for a purpose. Was the structure in the foreground an alter?

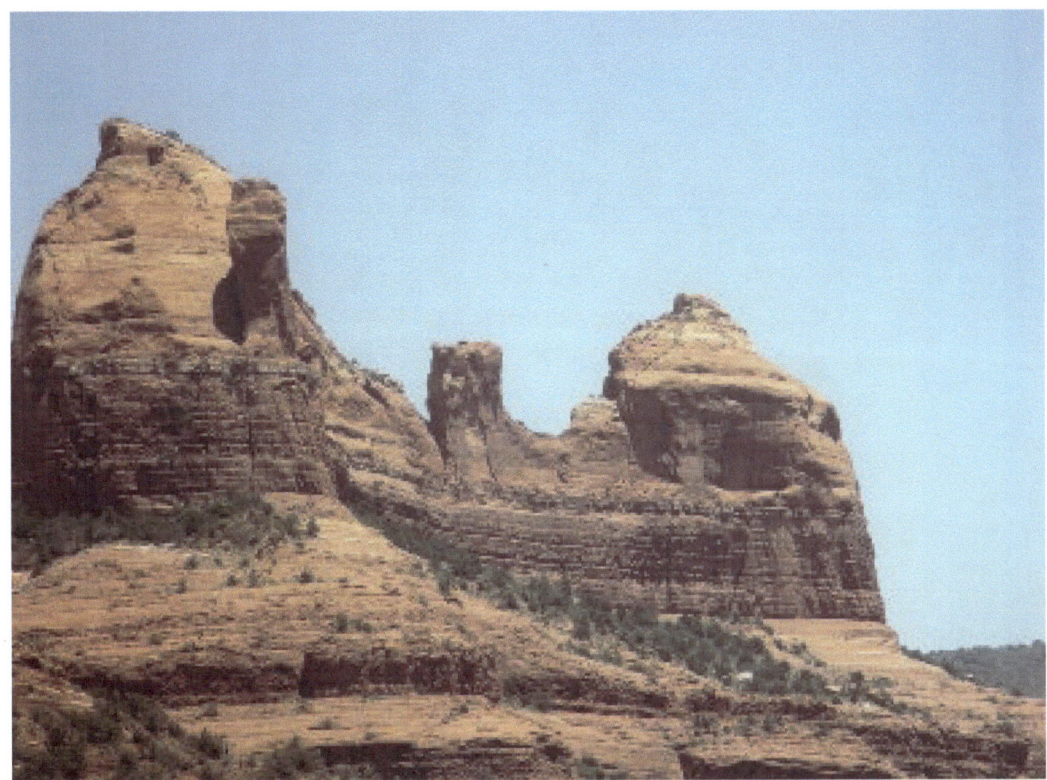

This fortress like rock formation in AZ reminds me of similar structures I've photographed in Coloarado and have seen in the Grand Canyon. Did the same creative intelligence constuct them using technology that's been lost? Perhaps!

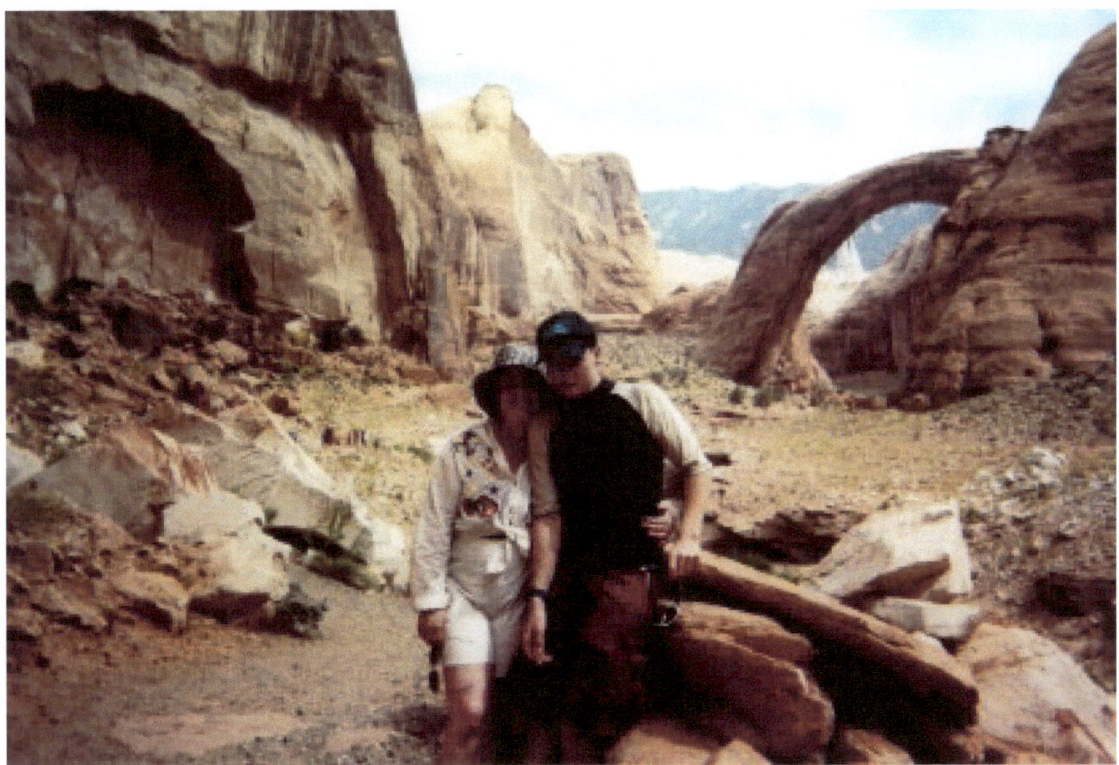

At Lake Powell, Utah with my son. I didn't recognize the ancient civilization evidence at the time. Now I believe the Lake Powell area is part of the same global ancient civilization. Above our heads it looks like there's a statue of a person (or an alien).

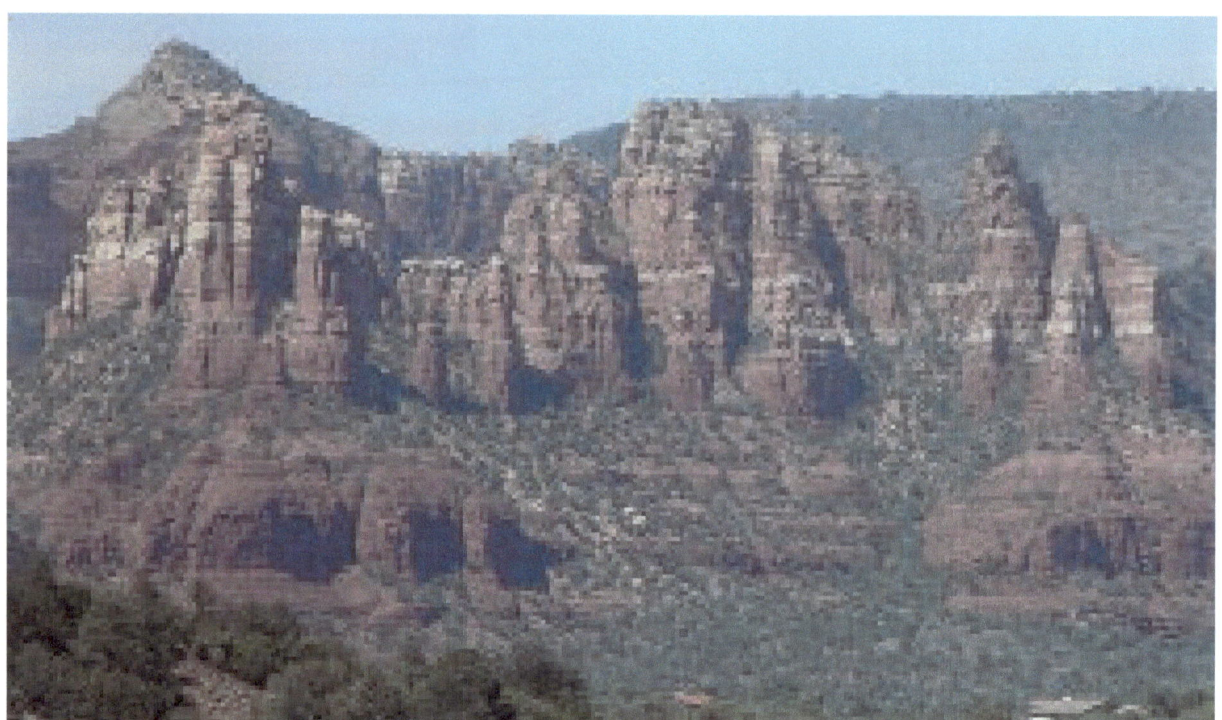

These rock formations near Sedona, AZ look surprisngly similar to the Grand Canyon.

This is a shot of the Grand Canyon. Similar construction to Sedona is obvious to me. What if the entire Grand Canyon was intelligently constructed and had little to do with the Colorado River? What if a million earth years was only a minute to those who created it? One must think outside the box to consider this idea of epic proportion. The curves, rock placement and erosion appear to support my theory.

Atlantis Risen UFOs and Orbs

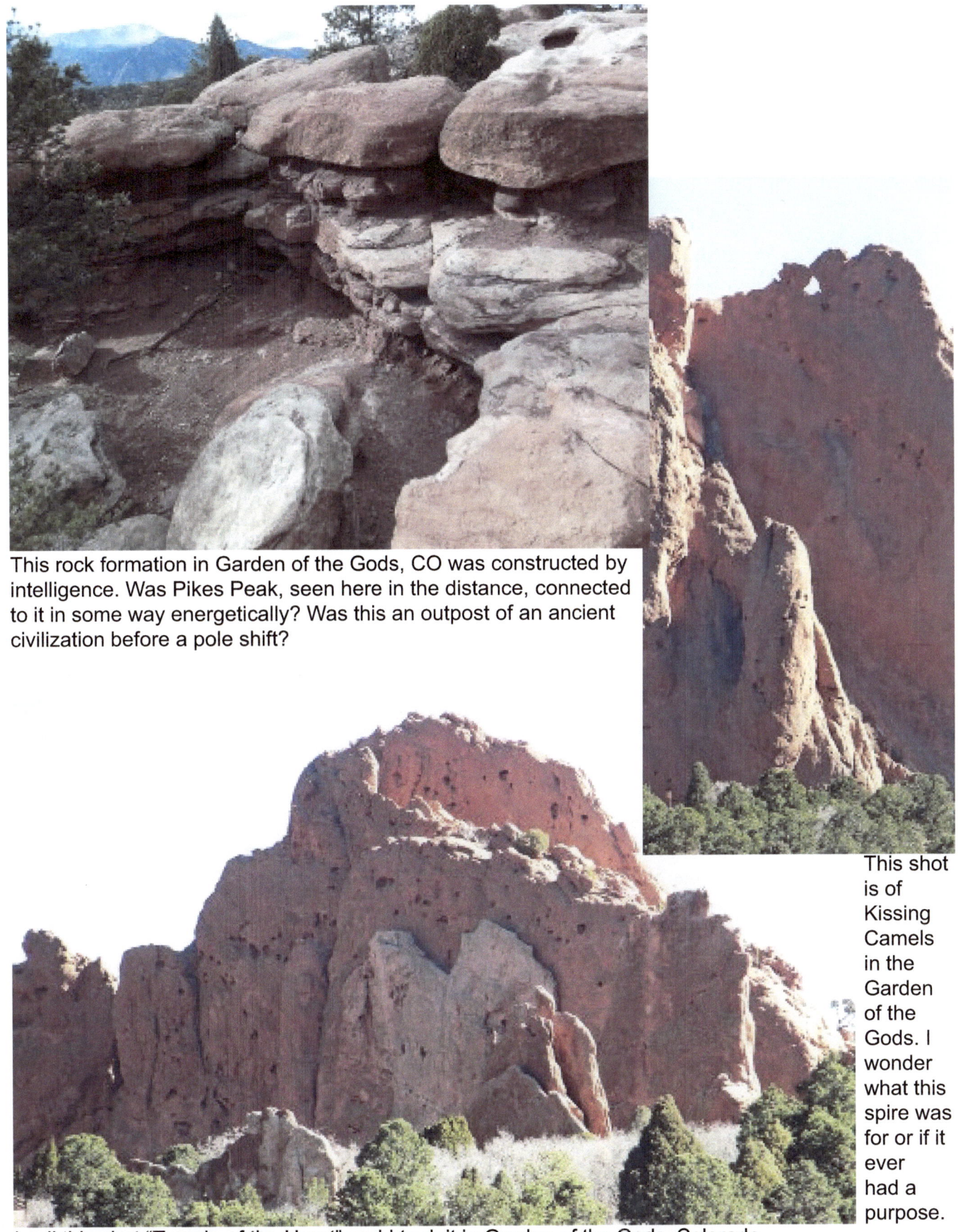

This rock formation in Garden of the Gods, CO was constructed by intelligence. Was Pikes Peak, seen here in the distance, connected to it in some way energetically? Was this an outpost of an ancient civilization before a pole shift?

This shot is of Kissing Camels in the Garden of the Gods. I wonder what this spire was for or if it ever had a purpose.

I call this shot "Temple of the Heart" and I took it in Garden of the Gods, Colorado.

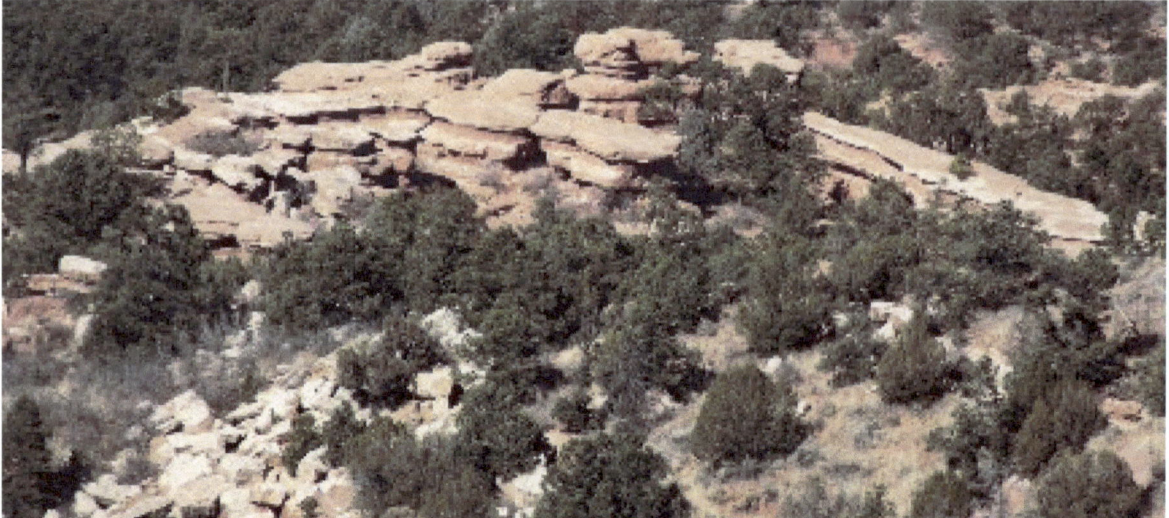

The rock formation shown here in the Garden of the Gods, Colorado, reminds me of similar construction in the Sedona, Arizona area. I believe they are connected somehow and that technology was used we don't yet understand. This layered structure may have been part of an ancient city.

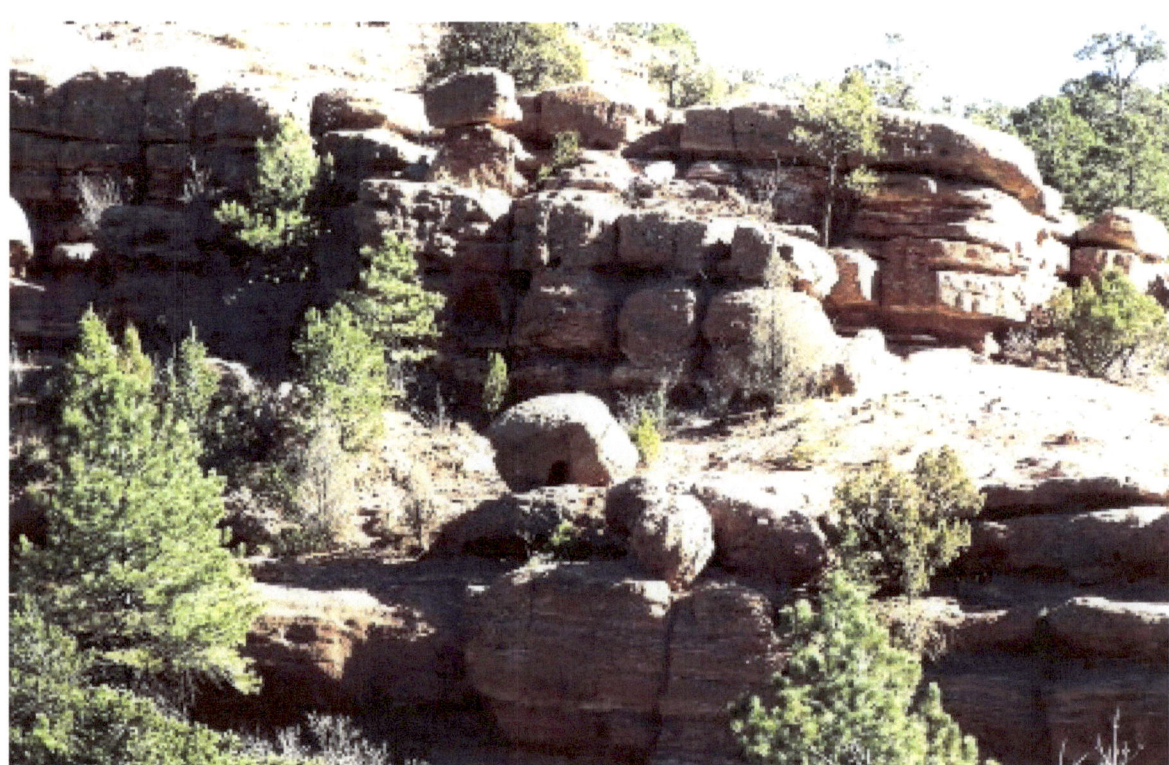

I call these type of rocks "block rocks" and they intrique me. They appear to have been grown or placed together for a purpose. The clearly constructed rocks with their angles and straight lines makes me wonder who, what, when, and why they were placed together this way. In the Garden of the Gods, Colorado.

An enlarged version of the shot below taken in the Garden of the Gods. These pictures support my theory of an ancient civilization.

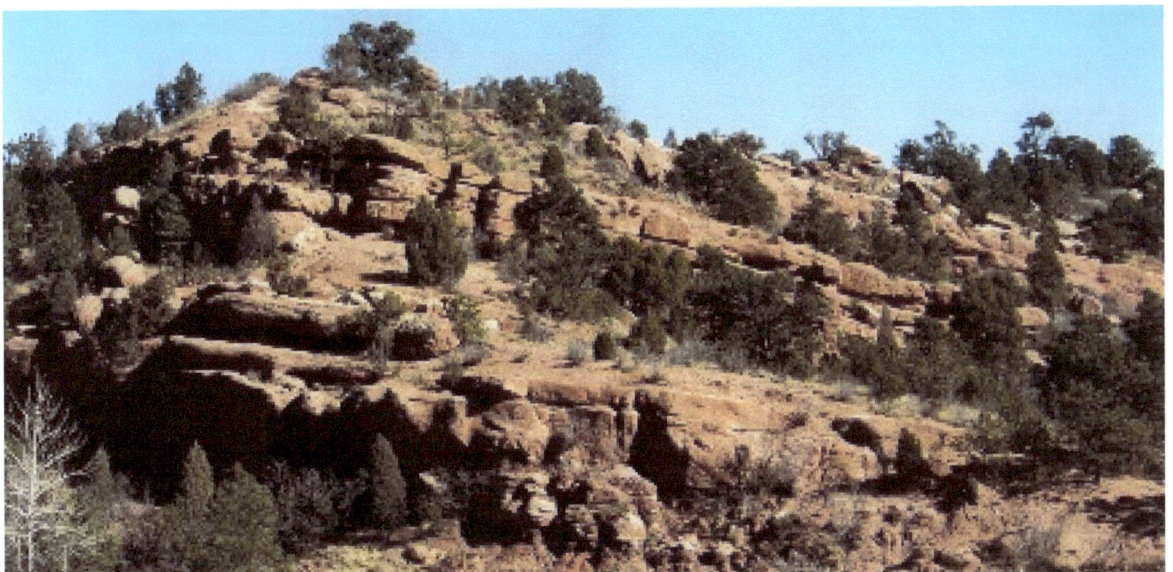

Before a cataclysm of some kind these rocks were probably not at this angle. I wonder what happened that caused them all to tilt? Were they cut and placed together, or were they melted in place somehow? Were they grown in cooperation with nature? There is no way in my mind that these appear random.

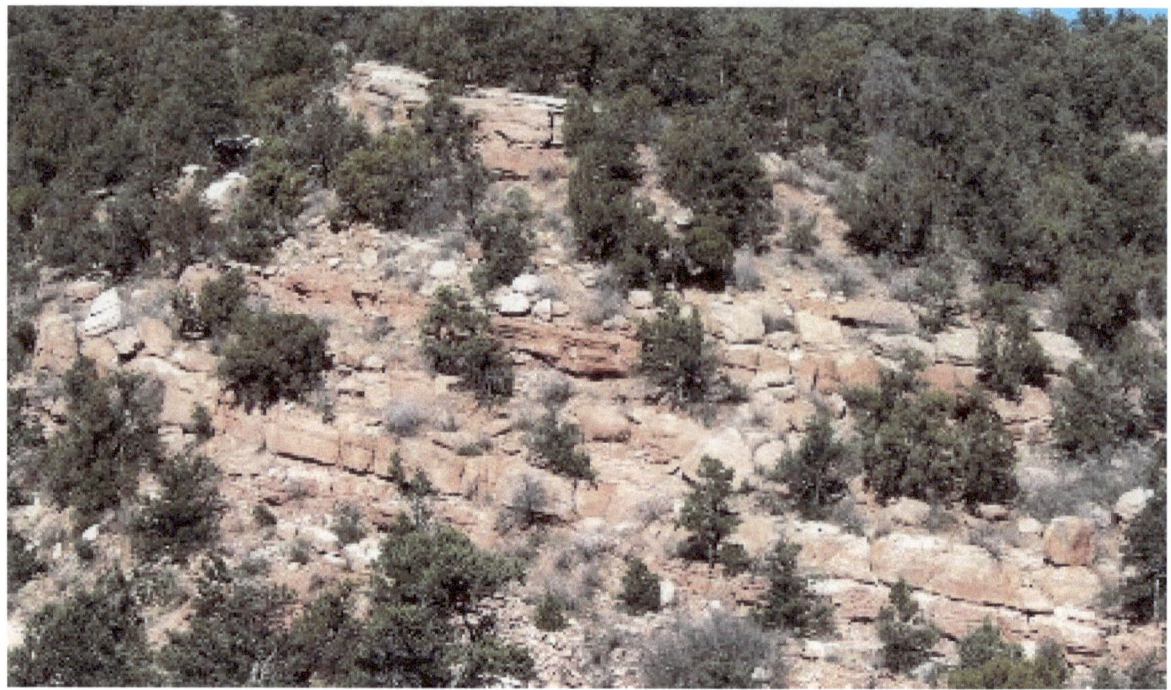

These two pictures were shot from HWY 24 beside Manitou Springs near the Manitou Cliff Dwellings. I have seen similar "block rock" formations globally and I think they may be linked to a very ancient civilization that once inhabited our planet very long ago.

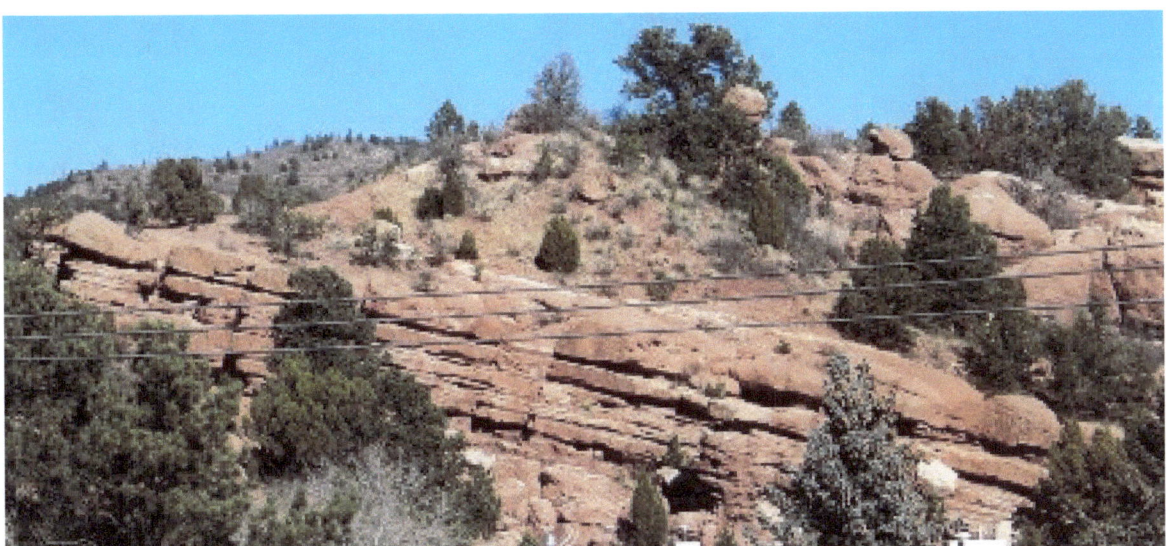
The perfectly parallel and perpendicular lines shown in these rocks brings many questions to mind. It looks like there's a small entrance to a possible cave in the lower center of the picture.

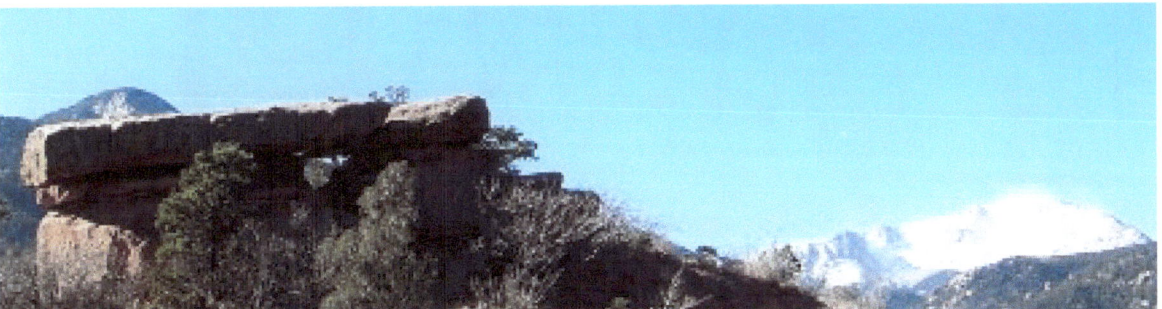
How did these strange rectangular rocks get on top of this hill near Manitou at the base of Pikes Peak?

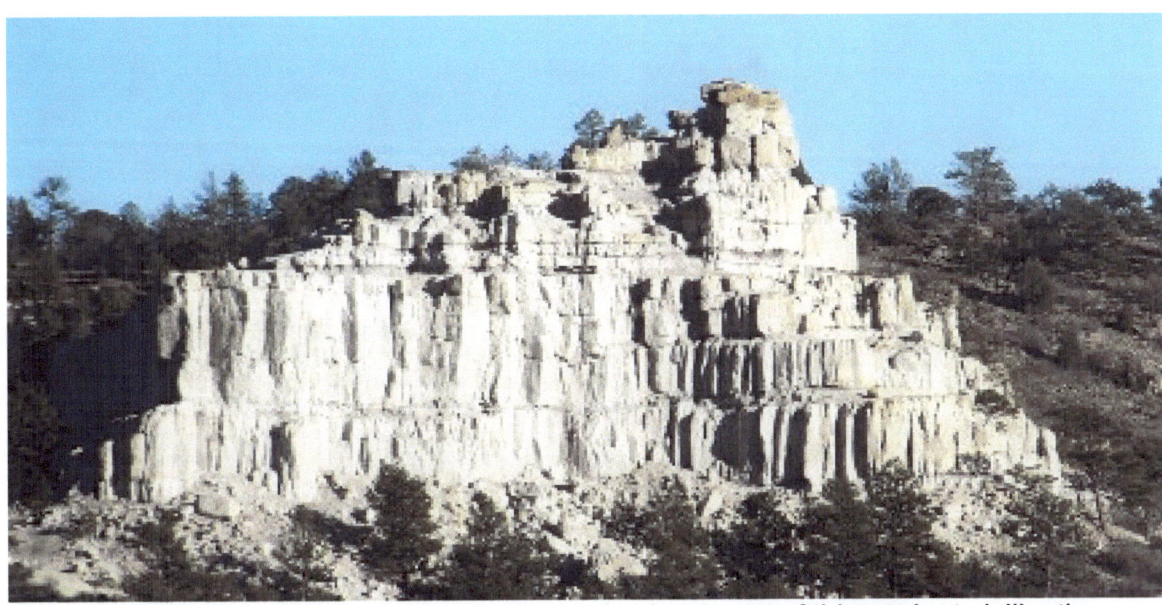
Pulpit Rock, in Colorado Springs, may have also been part of this ancient civilization.

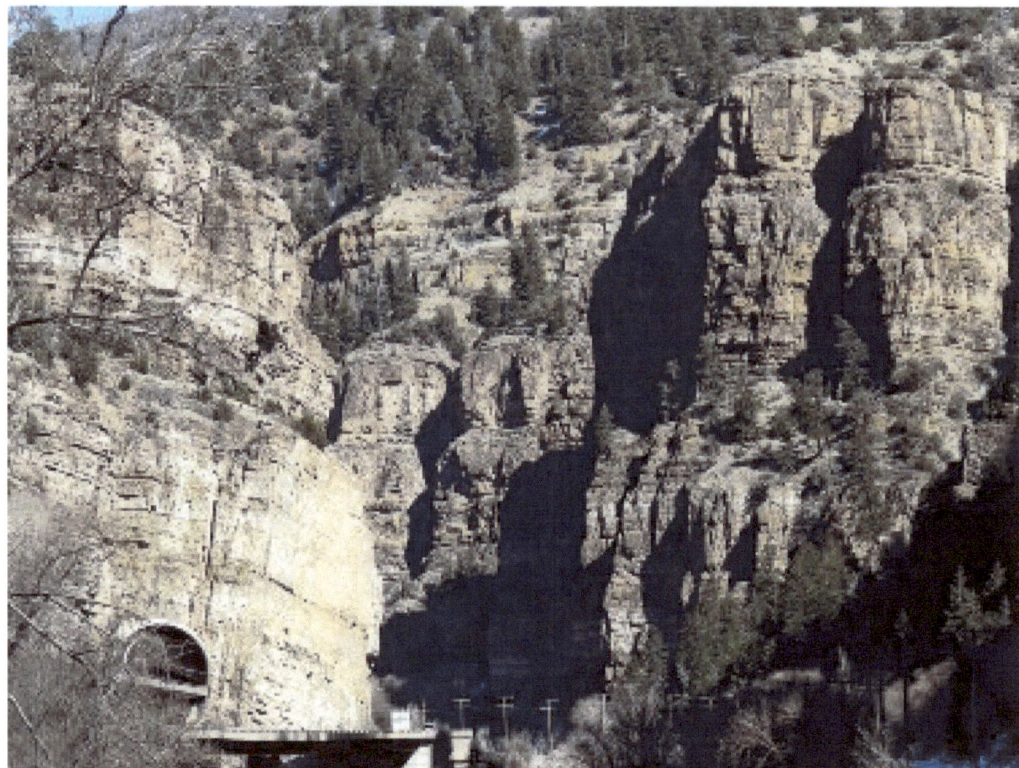

Along I-70 near Glenwood Springs, Colorado I noticed these rock formations that look like temple entrances.

These stone walls remind me of a temple entrance of some sort. It appears to me to have separate structures on different levels. I have no idea what these may have been used for or by whom, but I don't believe they were formed by "accident."

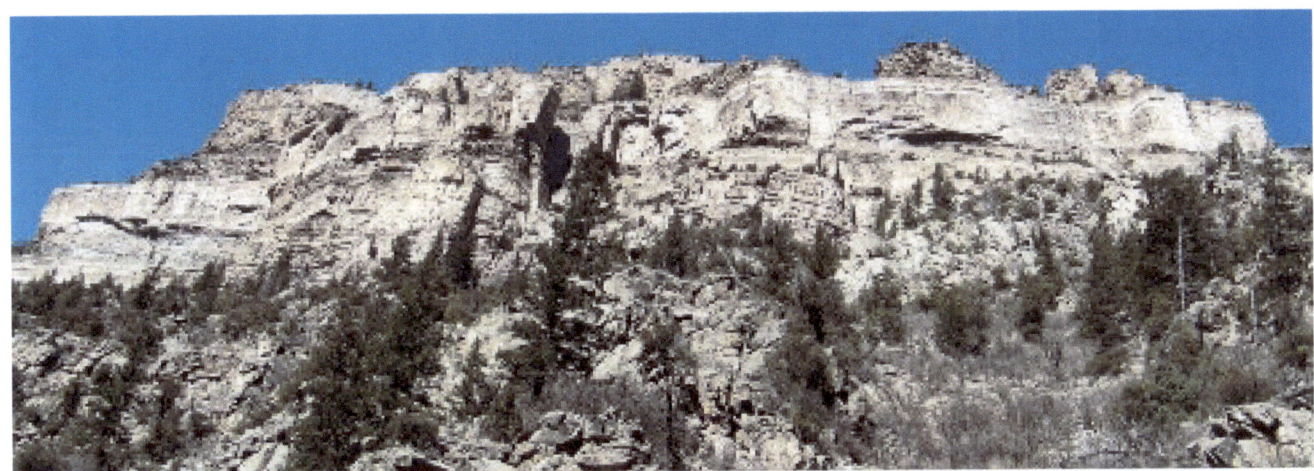

This stone fortress near Glenwood Springs, Colorado doesn't seem random. It looks like it was created for a purpose by an intelligent force to me.

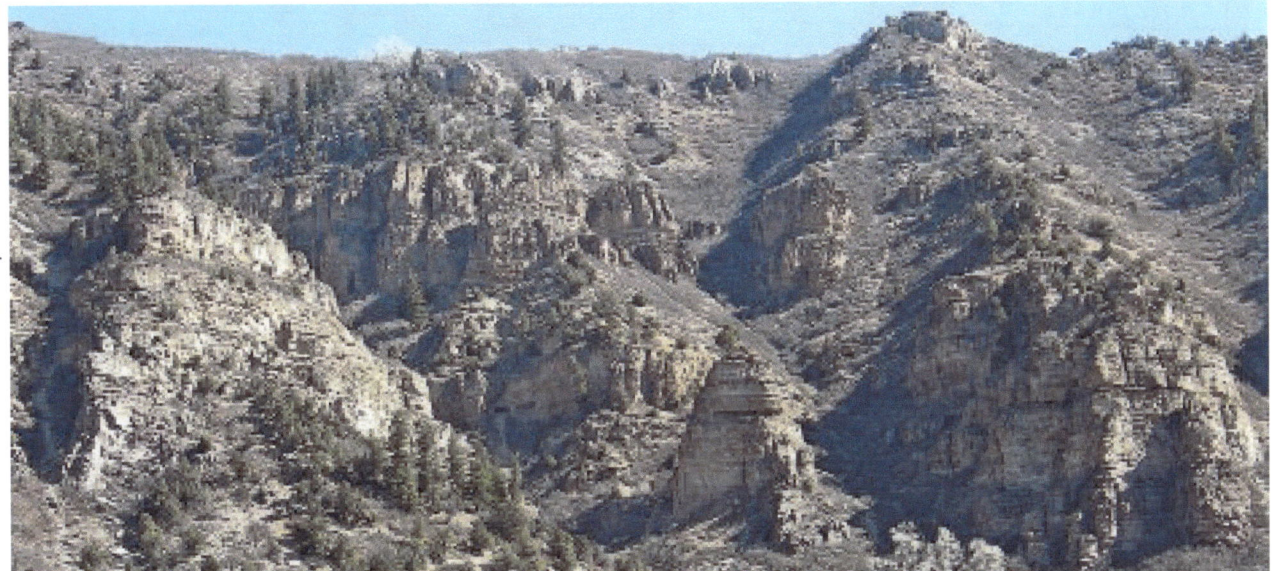

These rock formations near Glenwood Canyon, Colorado resemble an ancient temple structure. I believe they were created by an ancient civilization we have not yet considered.

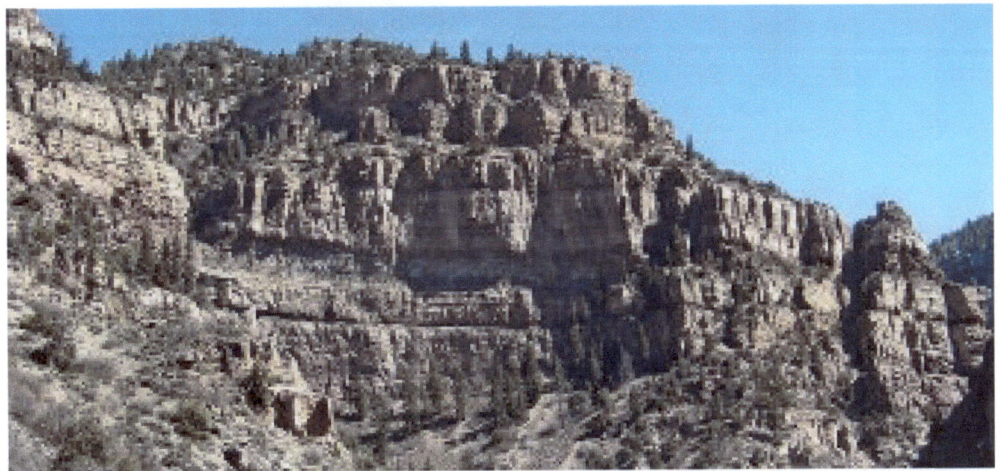

This formation reminds me of a fabulous fortress, with a grand entryway on the far right. Taken near Glenwood Canyon, Colorado.

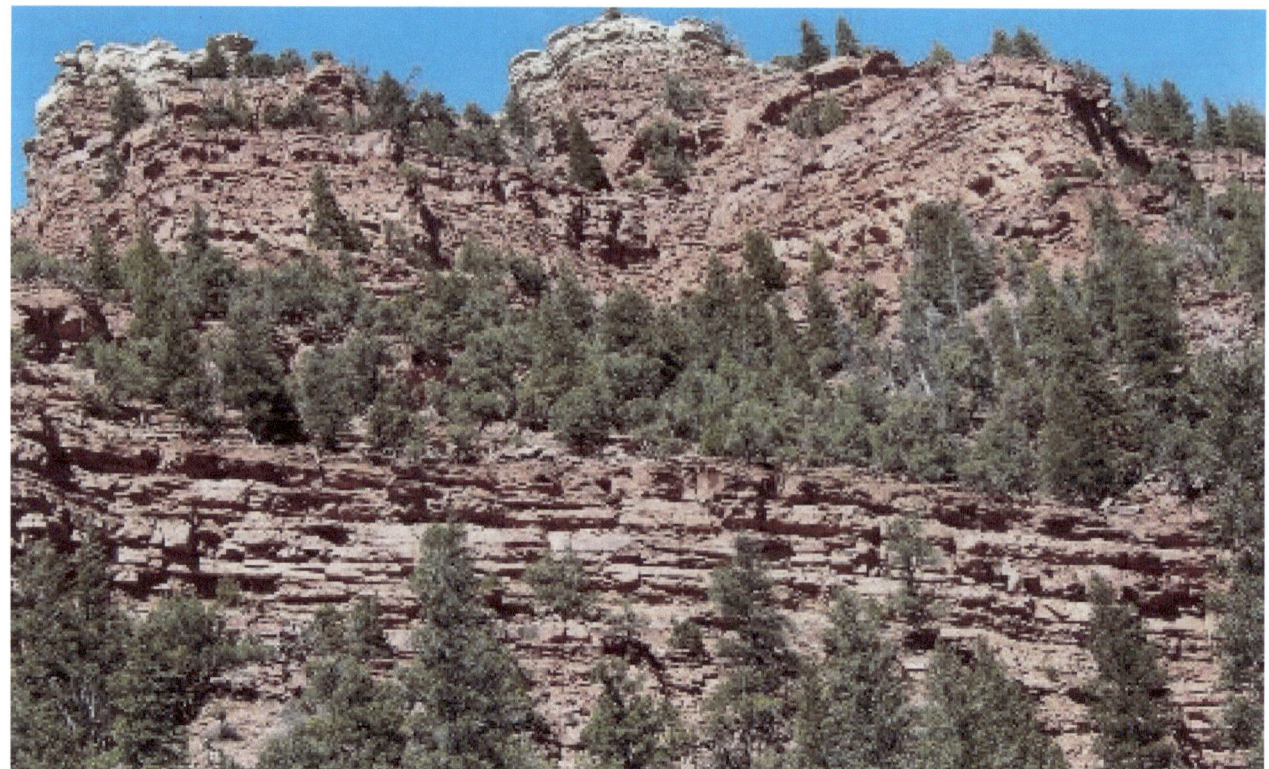
This amazing red rock fortress structure in Colorado could have been an outpost for an ancient civilization. It looks intelligently created to me. Maybe it was built by life forms that don't require bodies. Perhaps they still live inside it. Who knows.

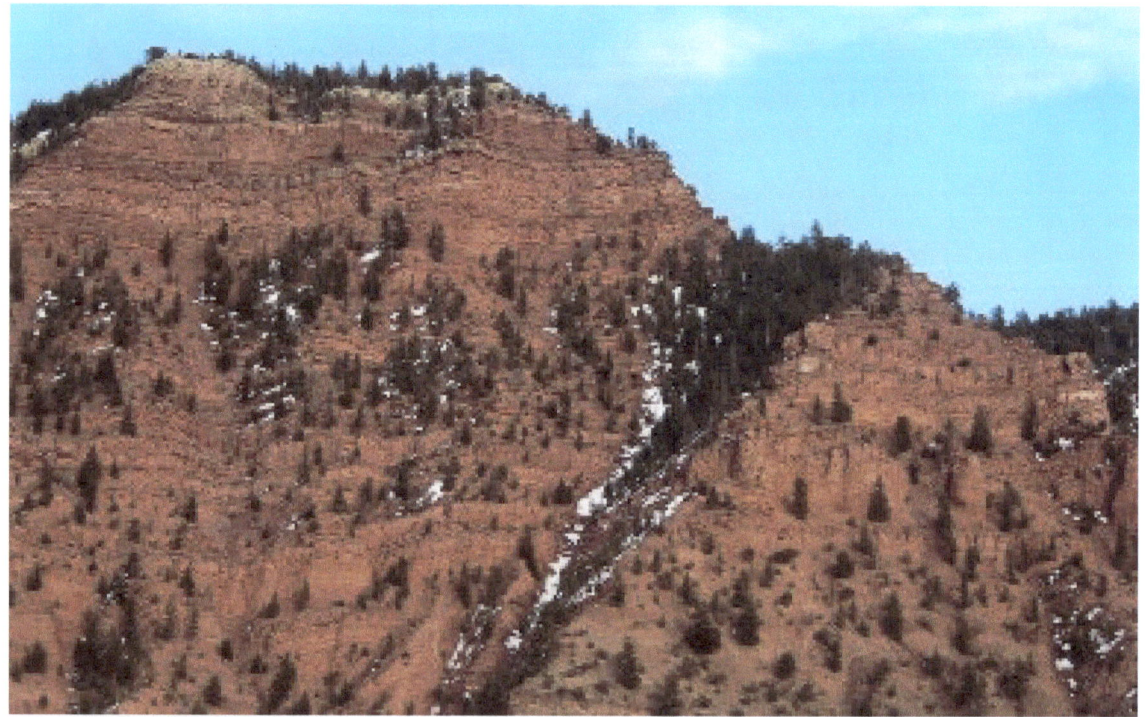
This red rock pyramid structure in Colorado may have been an outpost for the ancient intelligence that created similar structures globally. The perfect horizontal construction of the different layers peaks my interest. It does not appear random to me.

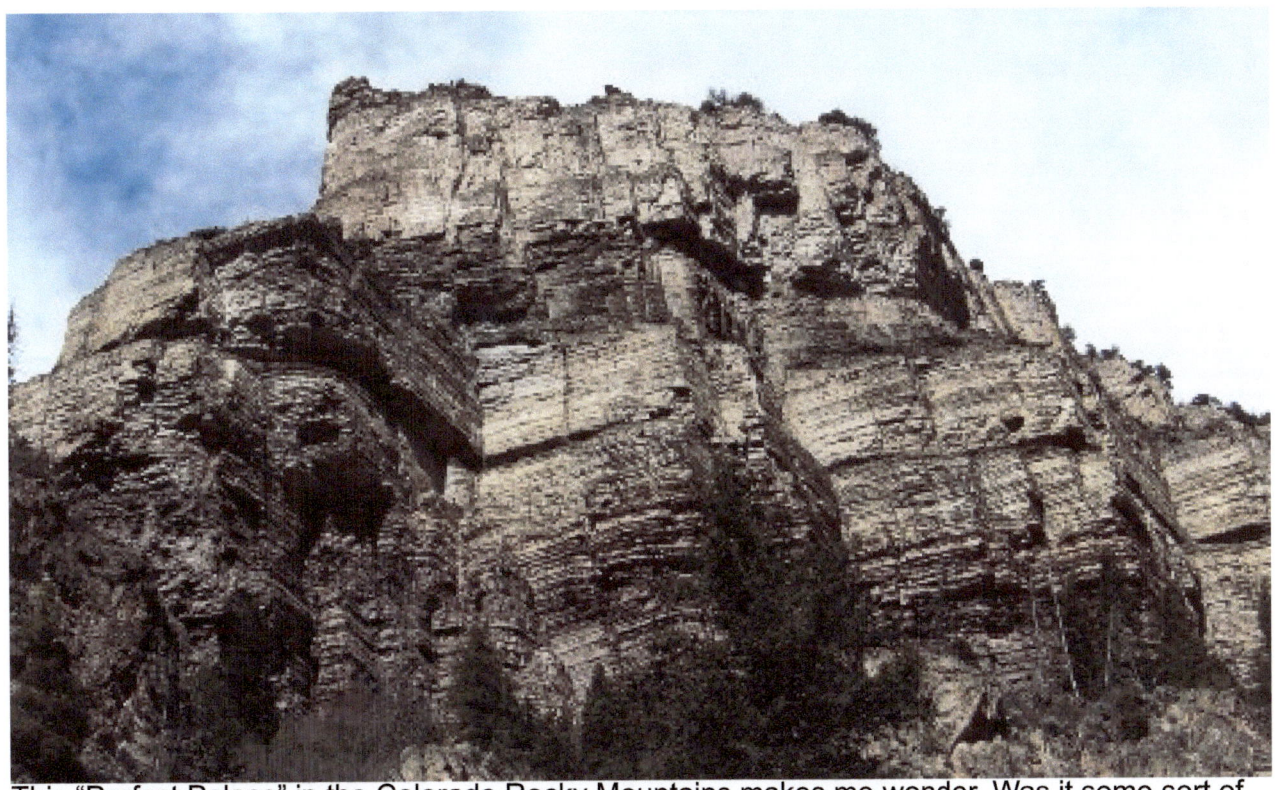

This Colorado mountain top fortress reminds me of several similar formations I've seen near Sedona, Arizona. I believe this ancient civilization was global in its reach.

This "Perfect Palace" in the Colorado Rocky Mountains makes me wonder. Was it some sort of communication relay tower from a grid that disconnected long ago? Is it hollow? What's inside?

UFOs

I believe Earth has been populated many times by civilizations we are not yet aware of. Like those who built the Nazca Lines in Peru, Stonehenge and other mysterious sacred places, advanced civilizations have come and gone. Are they still near, monitoring us? I believe they are our extraterrestrial ancestors or our future off-spring. Perhaps they will increasingly making their presence known. Here are a few pictures of UFOs I have taken personally.

My first sighting I remember took place at my mom's house in Mocksville, North Carolina in 1980. I was watching the stars when all of a sudden a light caught my eye. It came out from the tree line a few feet below the top of the trees. It was the size of a basketball and was bright and white. It took a ninety degree turn and shot down the tree line holding the same altitude in a straight line. When it got to the end of the tree line it took another ninety degree turn and shot down the road. It disappeared out of sight. I never saw it again. I did not notice the outline of a shape while watching it. It just appeared to be a ball of white light.

The next sightings I remember were during harmonic convergence in nineteen eighty-seven. I'd gone to Joshua Tree National Monument in California for a sacred ceremony with over one hundred and twenty other people. Then I arrived at the guard shack I noticed a bright flashing star just above the horizon which struck me as odd. It was flashing white, yellow, blue, green and red. I asked the guard about the star and she told me it wasn't a star and that it had been in the same location since sunrise. Very interesting. When I got to my campsite I climbed on top of a large rock formation and saw three more flashing lights at the same level above the horizon. Each was at a compass point marking north, south, and east. The light I'd seen originally was to the west. The flashing lights stayed in their positions until after our closing ceremony the following day when they just winked out.

The evening before the closing ceremony I saw a pair of small white lights very high in the sky traveling together in an erratic fashion. They'd do zigzags and loops then straight lines and slow curves. Since then I've seen video footage others have captured of lights performing similar maneuvers.

After the closing ceremony, I asked for a show of hands of anyone who had seen anything strange the night before. I was shocked when two thirds of the people raised their hands. I went around interviewing people and was amazed at the differences in their stories. Several children had seen shape shifting ships which changed from circular, to square, to triangular to diamond shaped and back. Others had seen glowing discs. Some had seen cylindrical shaped metallic objects. Some had received telepathic communications. A few claimed to have seen metallic discs land and others claimed to have been beamed aboard ships. This is when I realized that these objects are from other dimensions and what people experience depends of their own frequency, their own vibrations, their expectations and their intensions. After this mind expanding experience I have not judged anyone for what they claim to have seen, felt, or experienced.

Since harmonic convergence, I have seen many strange unexplained lights in the sky. I am often inspired while watching them or after having seen them and the ideas that come to me may have been suggested somehow by these lights.

I've also seen strange saucer shaped clouds I believe to be cloaked ships. I see these ship shaped clouds especially when I'm driving. I often broadcast thoughts of peaceful intention expressing my desire for contact. I let the Universe know that I'd like to see a ship and or meet those who inhabit it. It blows my mind how often the Universe responds with strange clouds during the day and flashing traveling lights at night.

Another UFO sighting took place August thirty-first of two thousand seven on the west side of Colorado Springs off King Street. I was living in my own apartment and heard a commotion outside. My neighbors were all excited because they were watching a UFO. I ran back inside and got my camera. I took twenty pictures of the object which appeared to be shape shifting or changing shape. It was visible for fifteen minutes, made no sound, and disappeared with an orange flash. I reported the incident to MUFON and sent copies of several pictures to them as well. Here's the report I submitted.

Detailed Description of the UFO Event submitted to MUFON
UFO Witnessed Near Old Colorado City, Colorado Springs, Colorado
7pm 8 31 07

My neighbors and I witnessed a UFO tonight. Three people watched as a medium sized metallic blue and silver object floated silently past our apartment. I did not see the beginning of the sighting, but was drawn outside by their excitement and watched as the strangest thing I've ever seen floated past. Two neighbors drew sketches of what they saw and I got pictures of the object. There was no sound. The sighting lasted fifteen minutes. I only saw the last five minutes. By the time I got outside, the object had passed...but I got a quick look at it before I ran inside and got my camera. I have a twelve power optical zoom on my digital camera and I was able to zoom in and get several pictures. I wish I'd been there and saw what they saw from the beginning. It had shining lights. The kids were outside playing and it came out of nowhere. Puny looked up and saw something very strange and asked Dumpy what it was. Dumpy had no idea. Her husband, who is a retired Air Force jet mechanic also had no idea what the object might be. There was no noise, no smoke, no chemical trails, no vibration of any kind coming from the object. There was a clear window on the object but no beings were seen inside. Lights shined brightly and evenly and changed colors from white to red to blue to green to pink to red...and the last color was a bright orange. At first they thought it might be a helicopter or a remote control plane or a glider because there was no motor. The object was shaped like a half of the Yellow Submarine from the Beatles...with a window on the front and a metal rod coming out of the bottom. It was silver and metallic bright royal blue. My neighbor Dumpy had been talking about UFOs just before the sighting occurred. It floated evenly with a constant speed in a straight line. We all felt peaceful during the sighting, and were all shocked and in utter awe. We'd never seen anything like it in our lives. The object floated way off into the distance until it was just a spot of flashing orange light and then it disappeared.

These are pictures of the object we witnessed and it appears to be changing shape from shot to shot. These were taken from a distance with a zoom lens. There appears to be plasma or something coming from the bottom of the ship. I have no idea what this object may have been but I'm glad I have pictures to prove we saw it.

Shape Shifting UFO
— I took these pictures near Old Colorado City, 8/31/07. They appear to show a craft "shape shifting." These pictures are of the same object but it appears to change shape from picture to picture. How is this possible? Please read the incident report I submitted to MUFON that describes the sighting and the circumstances surrounding it in greater detail.

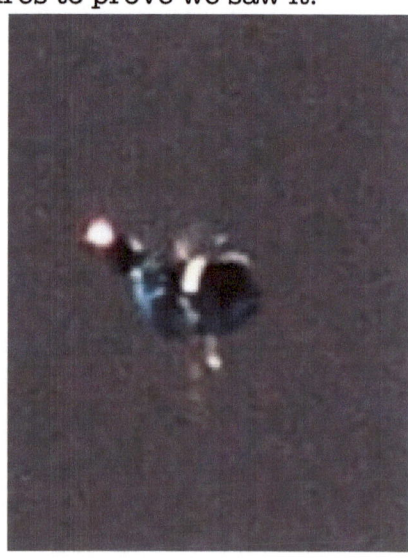

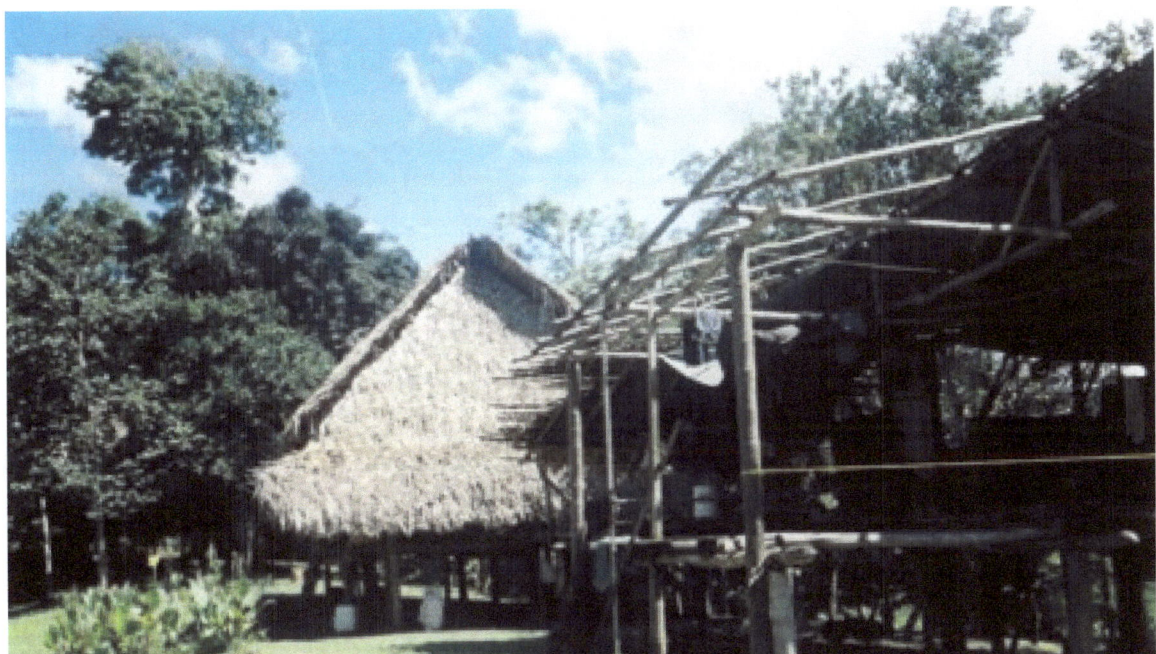

Panamanian Village – I took this picture at a native village on the Panama Canal which is only accessible by boat. The original picture (shown here) shows the primitive grass huts the society that lives here has used for centuries. What shows up in the sky above the grass hut?

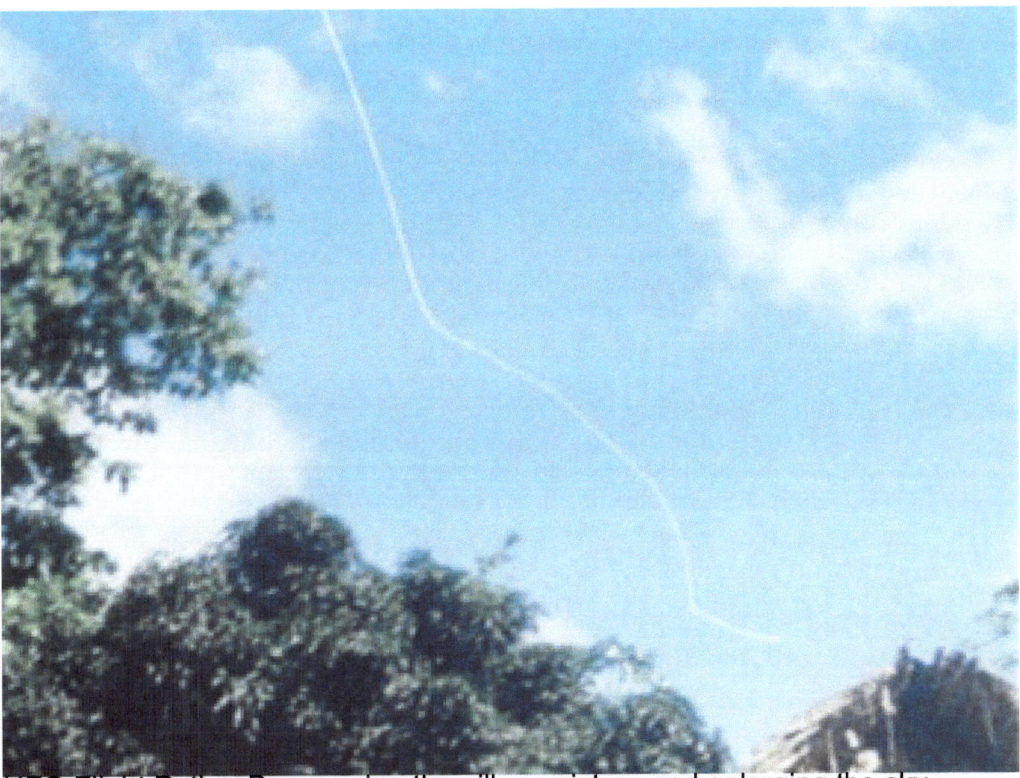

UFO Flight Path – By cropping the village picture and enlarging the sky section, a UFO flight path can be clearly seen. In the fraction of a second my camera took to take this shot, something traveling at incredible speed was captured digitally. Our current technology could not duplicate this flight path. Is this photographic evidence of craft from another time, place or dimension?

Another time (recently in December 2008) I began seeing a pattern on the walls repeatedly for a week in the evenings before I'd drop off to sleep. I asked the Universe what it could possibly be. Then I picked up a book called "The Serpent of Light" and began reading it. I was amazed to find a picture of the pattern I'd been seeing in this book. Apparently this pattern is called "The Flower Of Life" and is the basic sacred geometry pattern of life from which all things are created. I've since seen this pattern often.

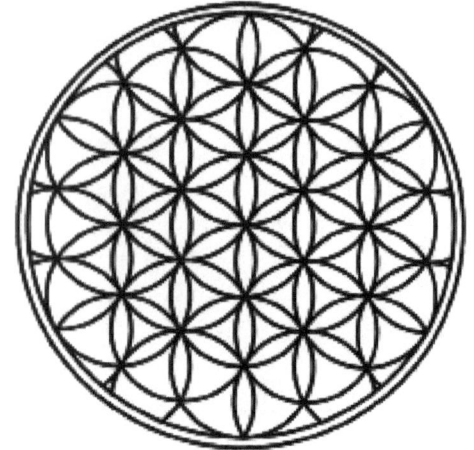

Flower of Life – The basic sacred geometry pattern of life from which all things are created.

My mom and I went camping and signaled the heavens with a laser light. Lights flashed back to us in the same sequence we'd used. I believe those lights came from a UFO. We were camped in Red Rocks twenty miles from Canyon City in Colorado.

Another sighting I had was during a break in Stan Romanek's presentation in Denver. Small white balls of light were visible high over head during the break. Stan claims ships are often present at his presentations. He's written a book called Messengers which I've read and highly recommend. Hopefully there will be a movie about his experience as well.

I decided to become more specific with my requests to the Universe. I sent more specific intensions out during meditation. I'd also speak my requests out loud. "OK, I know you're there but I haven't seen many of you. I'd like to see more solid metallic ships soon."

I went to Fountain Creek Nature Center near my mom's house in Fountain, Colorado. This area just happens to be very close to the base of NORAD which is a hollow mountain the military has used for strategic command. I did my energy exercises and had just finished doing my bows when I lay down to rest and relax. I was flat on my back looking at the beautiful blue sky that hadn't a cloud. Suddenly a small white cloud popped into view. It did not condense and grow. One minute it wasn't there and the next …poof…there it was. This seemed strange to me so I decided to watch it for a while. There appeared to be a ripple of energy surrounding it similar to heat waves coming off hot pavement. As I watched the cloud broke into two pieces – one large and one small. The larger portion of the cloud dissipated leaving the smaller portion behind. As it began to disappear I noticed a cylindrical metallic object behind it. The small cloud completely vanished leaving the dull silver or grey cylindrical object in clear view. It made no sound, did not move and had no exhaust. It was pointed on both ends and had no wings. It was visible for approximately fifteen seconds and then it just vanished. One second it was there and the next it was gone. I did not see it move or accelerate in any direction. It simply disappeared.

What I found extremely strange was that for the next three days I could see into another dimension. I don't know if this ability had anything to do with the UFO sighting but there are no coincidences so I believe the incidents are related. What do I mean when I say I could see into another dimension? Let me explain.

It was during the blue moon (which is the second full moon in a calendar month) in May of two thousand and seven. That afternoon I'd had the cylindrical solid metallic UFO sighting. I was living with my mom at the time and was sitting with her in her living room watching the evening news when all of a sudden I began to see a scroll coming towards me. It looked a bit like a movie introduction, similar to the "in a galaxy far far away" verbiage in the movie Star Wars. It was red with gold sacred geometry shapes. It was two dimensional at first and I could see through it. I've never had hallucinations. I asked my mom if she could see what I was seeing. She could not. I wondered if I should go to the hospital. I called my nutritionist and she said I was probably getting a glimpse into another dimension and that other clients of hers have reported similar experiences. According to her, as our vibrations increase and our energies shift more and more people will begin seeing into other dimensions. This information eased my mind so I decided not to judge or discount what I was experiencing and just go with the flow.

I watched the two dimensional wave of red and gold for quite some time. It was transparent and resembled sheer cloth traveling in an arch. Then it morphed into three dimensions and took up the entire room. It was the most beautiful thing I've ever witnessed (except for the aurora borealis or the northern lights). I watched it for another half hour and then went back to my bedroom. I continued to watch this energy display in my room. It changed again and there appeared to be a room full of orbs or light beings. They were so thick that it was more like solid soap bubbles. That's when I realized that the orbs I get in my photography are all around us all the time and that those that show up in pictures do so deliberately in an effort to communicate with us and show us we are never alone. After observing the orbs for a long time I decided to call in my angels. This is what I usually say to do that and often I light candles as I say the following:

"I call forth the Order of Malchezidec, Arch Angel Michael, Gabriel, Rhapeal, Uriel, Legions of Angels, my Beloved Lighted Ones, Mother Mary, Confucius, Jesus, Buddha, Mohammed, Quan Yin, the Great White Brotherhood of Light, the Ascended Masters, All the Angels and the Saints come to my assistance."

As soon as I finished saying this out loud, the entire room filled with angels marching in close ranks, shoulder to shoulder. Their rows marched from the ceiling to the floor and filled the entire room. There appeared to be thousands of them. They were transparent and had beautiful wings. I watched them for some time and then they faded away.

Over the course of three days I'd see energy flowing from all living things (and sometimes even non-living things like rocks). I could not will these visions to come or go. Sometimes I could see "into another dimension" and sometimes I couldn't. At one point I went outside on the back porch and could see energy all around me coming from the trees, the grass, all plants and even the clouds. It was breathtaking. At one point I could see the sound coming from a jet as it passed overhead. Don't ask me how because I don't know. All I know is what I experienced and I'm grateful that I did. I was sober and not on any drugs or medications during my three day visit between dimensions. It was a gift from the Universe that came and went.

Diary Entry 10/19/9 *I went back to Lea's where I was living in my camper to unpack another car load. I brought Mateso (a beautiful angel statue that stands over three feet tall) from moms, as well as my prayer flags, to decorate Lea's porch. I helped Lea with plants in her BIG green house. Later that evening I watched Dancing With The Stars for the first time with Lea. I loved the costumes. After the show I puttered in the camper and organized it a bit.*

Later I was star gazing outside when I noticed two UFO's zigzagging in the sky over Lea's house for about fifteen minutes. Later, I was lying in bed in the camper (above the driving compartment) when a bee started circling the light near my head. I thought this peculiar because in all the time I've had the camper I've never had a bee drawn to a light. I knew I had to turn off the light to break the spell, so when I opened the camper door the bee would leave. It worked. He flew out just as I opened the door. Then I immediately noticed more moving lights in the sky. Maybe the bee was trying to tell me something. I'll never know. At any rate these two UFO's were traveling together in crazy patterns. I never would have seen them if it hadn't been for the bee. They behaved like dancing stars and traveled up and down then diagonal and all around in seemingly endless combinations. I watched them for more than five minutes but then retired to my camper because I was freezing. I don't know how long the ships played outside. I wonder if the lights I'd seen earlier were the same as these. I found it interesting that I'd seen what appeared to be stars dancing after having just watched Dancing With The Stars! I've heard it said and I agree…there are no coincidences. I decorated the camper walls with butterflies and angels I'd brought with me when I went back inside. I feel content and know for certain that I will sleep well tonight.

Here's an article that appeared in the Colorado Springs Independent newspaper April 11-17, 2012 issue by Chet Hardin. I gratefully reprint it here with permission.

NEWS

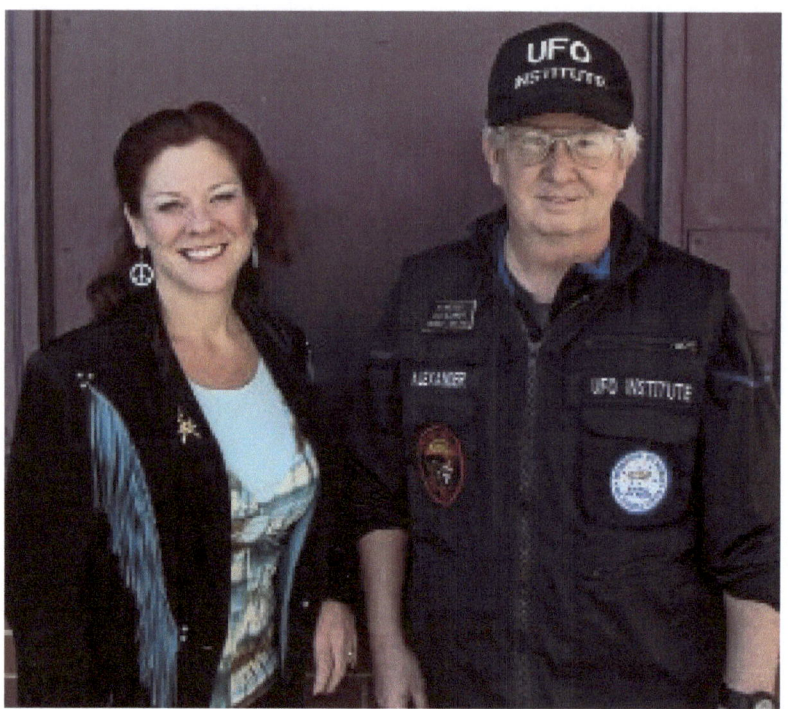

Elise Eagle and Steven Alexander think this area's geography already appeals to UFOs. Photo by Rebecca Tillett

Alien hunting

A local retired Army officer indulges his long-time interest in the paranormal, with others joining him

There is a hypothetical grid of invisible lines, known as ley lines, that delineate our planet's surface.

The Great Pyramid at Giza happens to be on a great intersection of ley lines, and Sedona, Arizona is too,: says Elise Eagle, "and so is Garden of the Gods. There are places on the planet that are actually more attractive, because these ships actually use this grid to maneuver."

The ships she's referring to? They're UFOs, perhaps like the shape-shifting object she photographed flying over Old Colorado City not long ago.

"This is all interdimensional and frequency-vibration-based," Eagle continues. "And it all depends on your interpretation of reality. Someone might be standing right next to you, and you see something and they don't.

Eagle serves as communications coordinator for the twice re-booted UFO Institute, a local group of extraterrestrial enthusiasts. She met the group's founder, Steven Alexander, in 2007.

Alexander was involved at the time in a tricky balancing act: exploring an alien obsession that began in the early 1990's thanks to the wildly popular TV series, The X-Tiles, and the demands for discretion that come with being an officer in the Army Reserves.

A 1972 Air Academy High School graduate, Alexander joined the Colorado National Guard in 1983. From 2003 to 2011, he was active-duty, doing two tours in the Middle East and earning a Purple Heart. Last May, he retired as a lieutenant colonel. Now, at age 58, he's free to explore his eccentric interests unfettered. In addition to his work with the JFO Institute, he's wrapped up another novel, after writing three that have spanned coming-of-age tales, historical fiction and, yes, the paranormal.

Of course, as any UFO follower will attest, truth is often stranger than fiction.

"Yeah we've had people at our meetings who say that they are extraterrestrials," says Eagle, a former engineer with IBM and Ingersoll Rand. "And who are we to judge? They really believe that they are, and they're welcome."

"That's what's neat about our group," adds Alexander. "Our doors are open. The person three seats down might say that they're dating someone from Venus, and we have to just go along with it."

"We've had people talk about Sasquatch at the Air Force Academy," offers Eagle.

A woman who serves on their board believes that aliens have moved in with her.

On the other hand, Alexander says, some of the most fascinating stories he's heard come from ex-military members. Like the retired Air Force pilot who chased aliens in an F-4 Phantom across Laos and Cambodia in 1969.

Eagle and Alexander want to hear everyone's stories, regardless of how bizarr they might sound, to advance the study, evaluation and documentation of UFO sightings.

There was a time, says Eagle, when discussing your alien encounter was considered taboo – a good way to alienate friends and family. "But thhings are changing now. The veil is lifting. Consciousness is expanding. We are waking up, so more and more people are beginning to see the ships, or faeries, or the other dimensional phenomenon."

And being in Colorado Springs, they say, offers a great front-row seat for this lifting of the veil.

The UFO Institute meets at 7 p.m. every third Tuesday in the Carnegie Room at Penrose Library. – *chet@csindy.com*

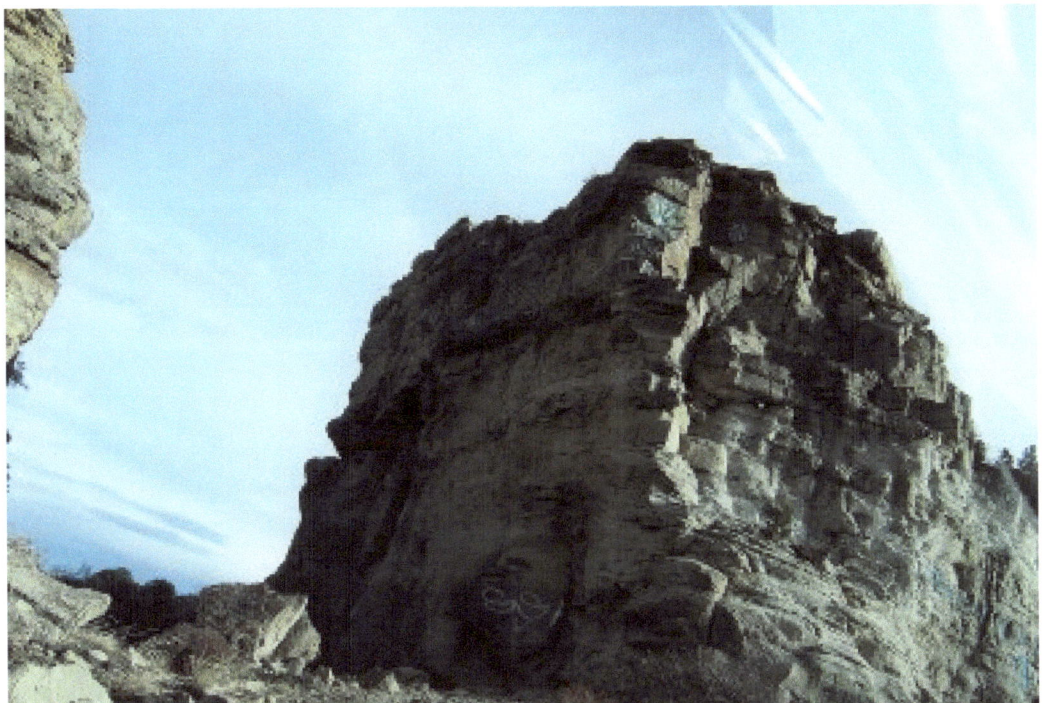

My friend, Michael Comora, took this picture near Trinidad, Colorado. He did not notice what was going on in the upper right hand corner of the picture...but I sure did!! What energy created the perfectly parallel diagonal lines the ships appear to be following? What could explain the curved line directly above the rocks and just below the smaller craft? Could this illustration suggest how energy can be manipulated? Is this energy manipulation how the rock formations shown earlier were created?

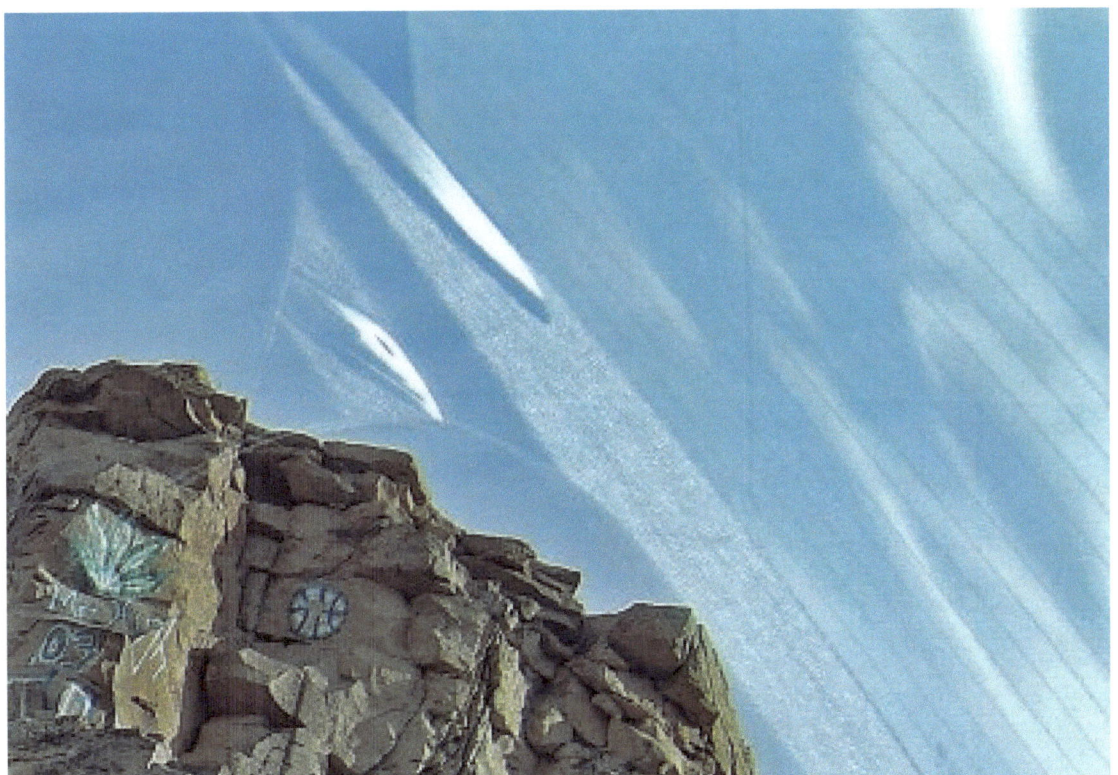

I cropped the picture Michael Comora took and adjusted the lighting in Adobe Photoshop. I did not add the lines, the curves or the inter-dimensional ships that showed up. Is this a glimpse into another dimension? Are there ships shown here?

Orbs and Light Beings

I am fascinated by orbs. For several years now orbs have been appearing increasingly in my photography. What are orbs? I believe they represent intelligent consciousness. Consciousness is what we are without our bodies. I call orbs 'light beings', but there are also rainbow light beings that appear to be different than orbs.

Light beings show up in my pictures during times of celebration. They seem to be attracted to joy and the increased vibrations some types of music create. I've got hundreds of pictures of orbs taken during concerts, weddings, funerals, dances and other sacred ceremonies. I believe they are showing up more often at this time because the veil between dimensions is thinning. Orbs exist in the fourth and fifth dimensions and because humanity is increasing its vibration and many people are expanding their awareness and their consciousness, more and more orbs and UFOs are showing up. We are not alone.

The following is part of a research paper that was presented at the 1996 MUFON International UFO Symposium in Greensboro, NC, July 5-7 by John W. White. I believe what he refers to as "critters" are what I refer to as orbs: *"Other UFO experiences in the terrestrial category seem best understood as human contact with a lower form of animal life native to Earth's atmosphere. The discovery of these strange aerial creatures is told in Trevor James Constable's 1976 book The Cosmic Pulse of Life. He simply calls them "critters." His text and photographs reveal a class of elemental fauna unknown to official science. These amoeba-like aeroforms are neither solid, liquid nor gas. They exist in the forth state of matter - plasma - and are normally invisible for several reasons. First, their native habitat is high above the atmosphere far beyond human gaze but nevertheless well below the astronomers' usual telescopic focus. Second, they are bioenergetically propelled and move at a very high speed - thousands of miles per hour. Last, their usual condition is in the infrared portion of the electromagnetic spectrum. However, they have the capacity to change their density and thereby pass from one level of tangibility to another. Thus, they sometimes do appear in the visible portion of the spectrum, if seen by humans, they are quickly labeled UFOs - which, of course, they are. But they are not mechanical spacecraft; they are living creatures. They grow anywhere from the size of a coin (such as the World War II "foo fighters" sightings) to at least half a mile in diameter. They give a solid radar return, even though invisible to the naked eye. When they're visible, they pulsate with a reddish-orange glow. They can change their form, but generally are seen as discs or spheroids. Their diaphanous structure allows a limited view of the interior."*

I do not know if orbs are a "lower" form of life. I can not verify that they can be seen on radar, as mentioned above, but I do know they grow larger than a half mile in diameter. If one views the NASA footage on Youtube of the space shuttle tether that broke, orbs over two miles wide can be clearly seen in the atmosphere. I found the quote above to be an interesting summary of the orb phenomenon.

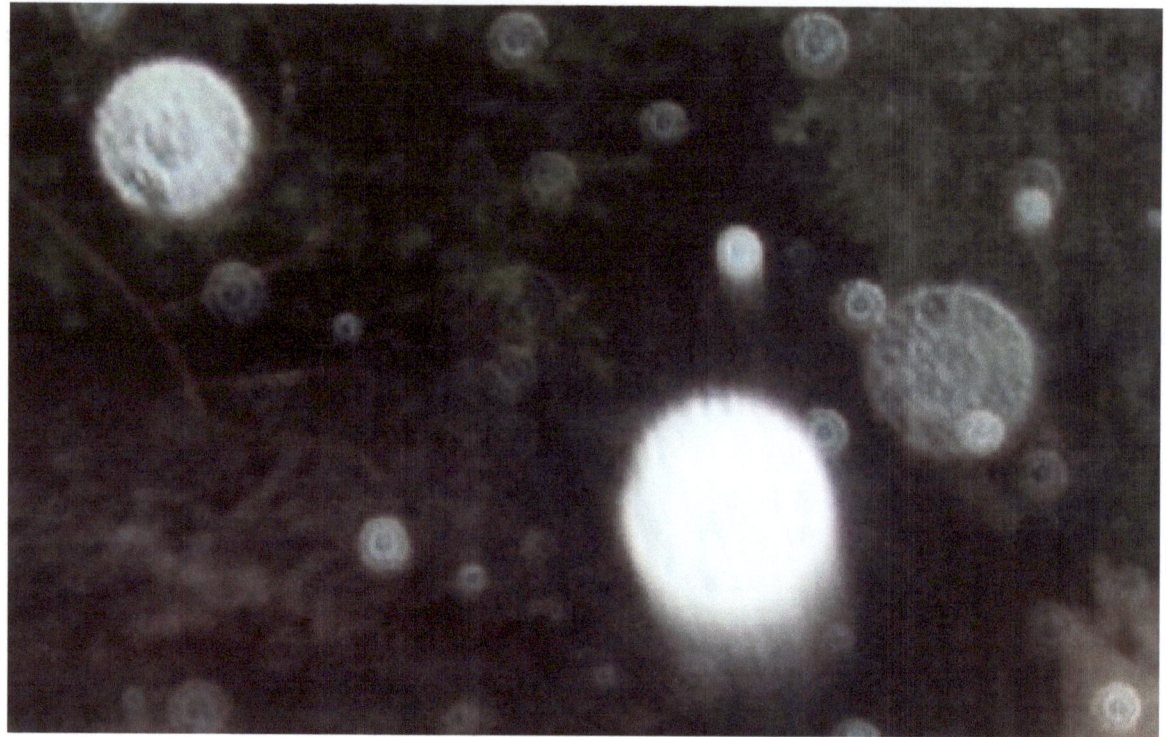

Orbs in Action – I was with my friend Jamie Adamson when she took this picture near Garden of The Gods, Colorado. There was a slight drizzle that day, but rain travels down…not up. It appears the orbs in these pictures are traveling in the opposite direction rain would fall. I call these orbs "rainbow snowflake light beings." The geometric patterns within the orbs themselves interest me.

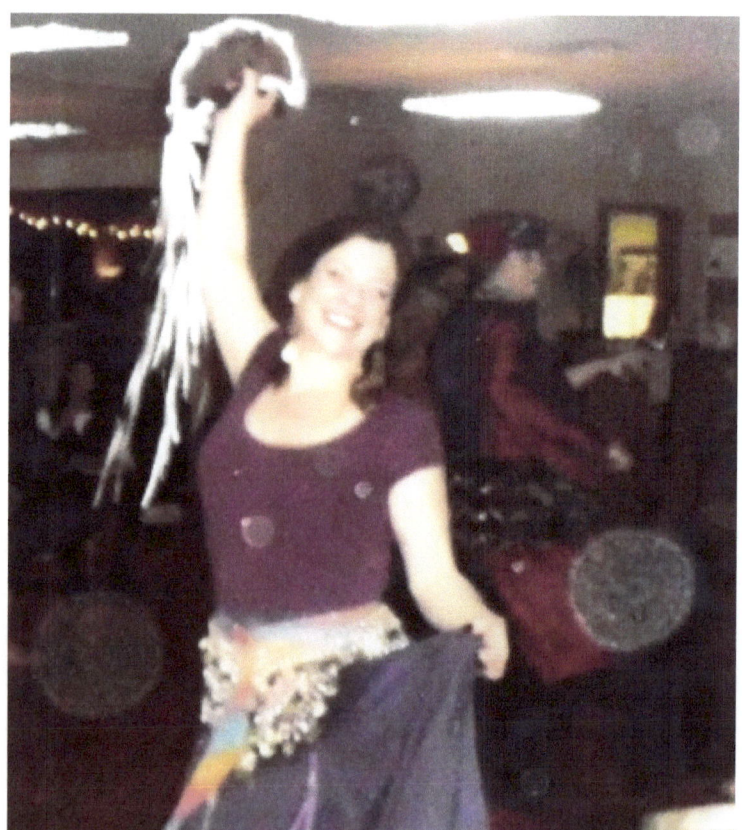

Big bright orbs appear while I'm dancing at a full moon drum and dance circle, 2011.

Atlantis Risen UFOs and Orbs

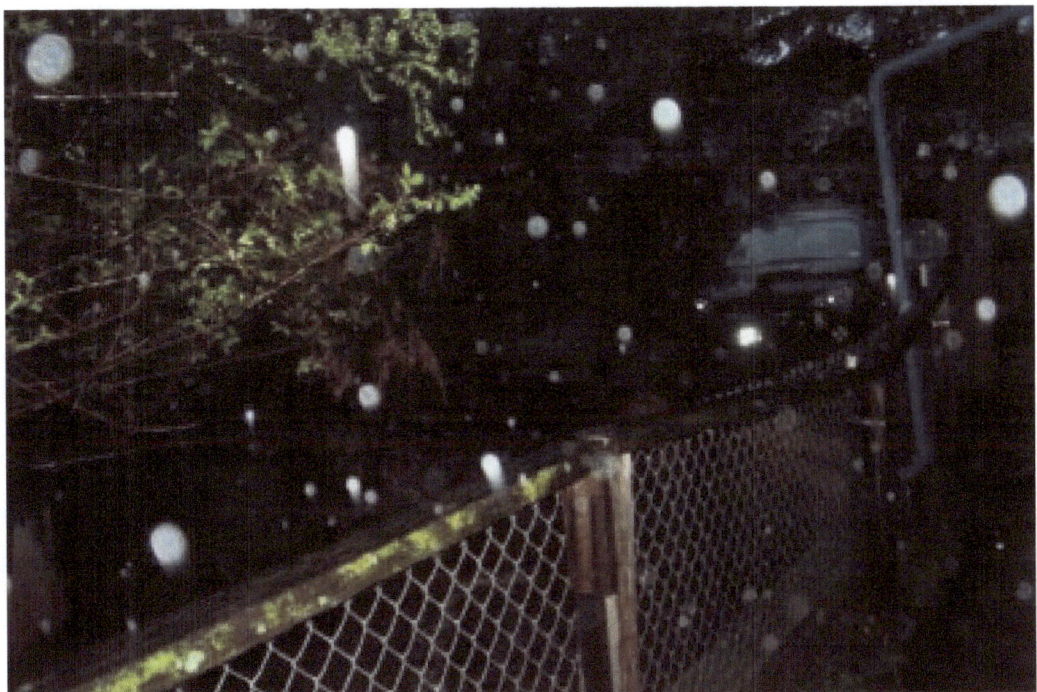

I was with my friend Jamie Adamson when she took this pictures near Garden of the Gods, Colorado, 2007. There was a slight drizzle that day, but rain travels down...not up. It appears the orbs in this picture are traveling in the opposite direction rain would fall. I call these orbs "light beings" and I believe they represent intelligent consciousness.

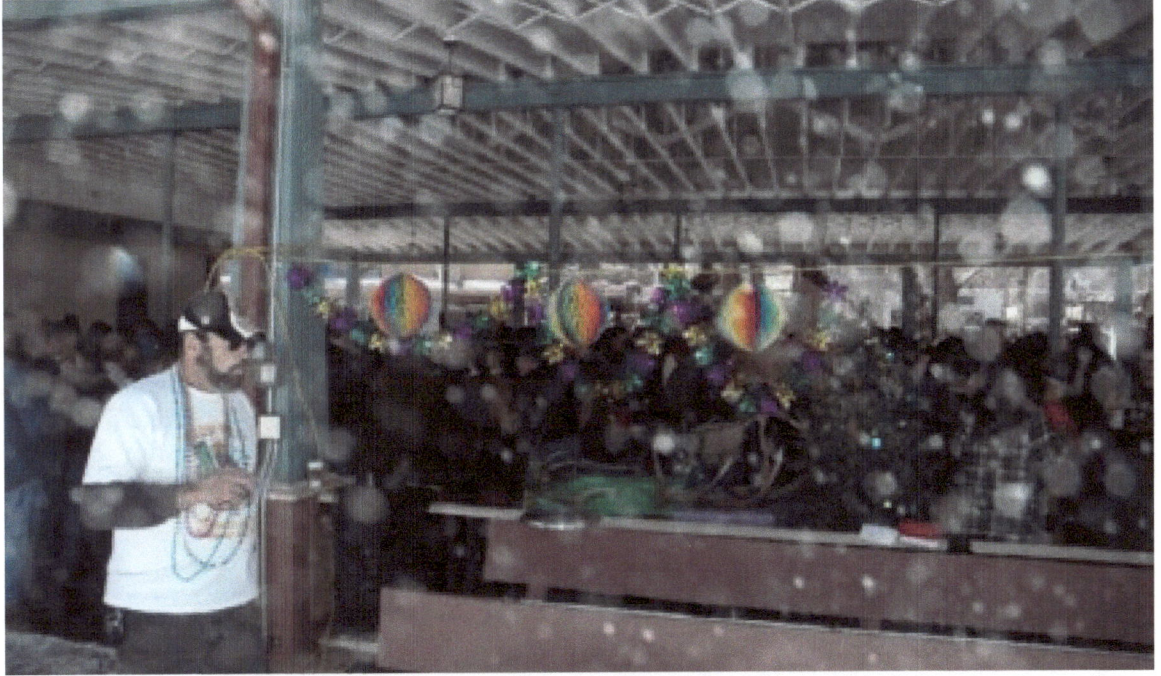

My friend Mike Coletta took this picture at Soda Springs Park, Manitou Springs, CO. It was not snowing or raining at the time, and the pictures he took before and after this shot had no orbs in them. This picture was taken right before the Carnival Parade one year and I believe the orbs showed up in honor of the celebration. The paper "rainbow balls" hanging from the ceiling are decorations, not orbs. It's easy to tell the difference.

This picture was taken by a friend at Slot Canyon, Arizona, 2006. These bull's-eye or target orbs appear to have depth. I have no idea what the difference in orb appearance means but I find the variety among orbs fascinating and worth further investigation.

I took this picture of my mom at Halloween 2007 and later noticed two orbs near her head. These orbs don't appear to have designs in their interiors. She had already taken off her witch costume but hadn't removed her green face paint. It's not something she ate! I think the orbs showed up because they are playful and enjoyed our handing out candy and the good vibes the children brought with them as they trick-or-treated.

This orb appears to have a face. This shot was taken at the finish line of a race my friend ran. He didn't notice this great orb until I pointed it out. So many people just have never noticed them before, but I hope to help change that. I think they are important and should be noticed.

With my dear friend Heidi Cooper Oct. 23, 2011 at the Witches Ball at the Center for Spiritual Living in Colorado Springs. Notice the bright orb above the door in the upper right of this picture. I won first prize in the costume contest and was SO very proud! What a fun memory.

Drumming with my friends, Tony Kisling and Virginia Geist, joined by a clear orb above my head.

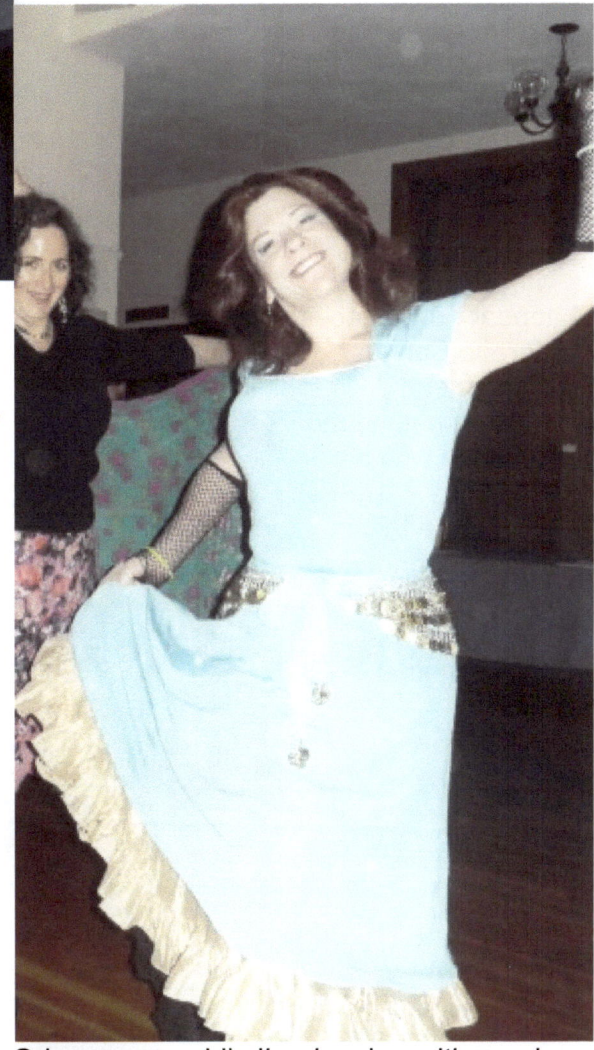

Orbs appear while I'm dancing with my dear friend Dana Merrill Gass at All Souls Unitarian Universalist Church in Colorado Springs, 2012.

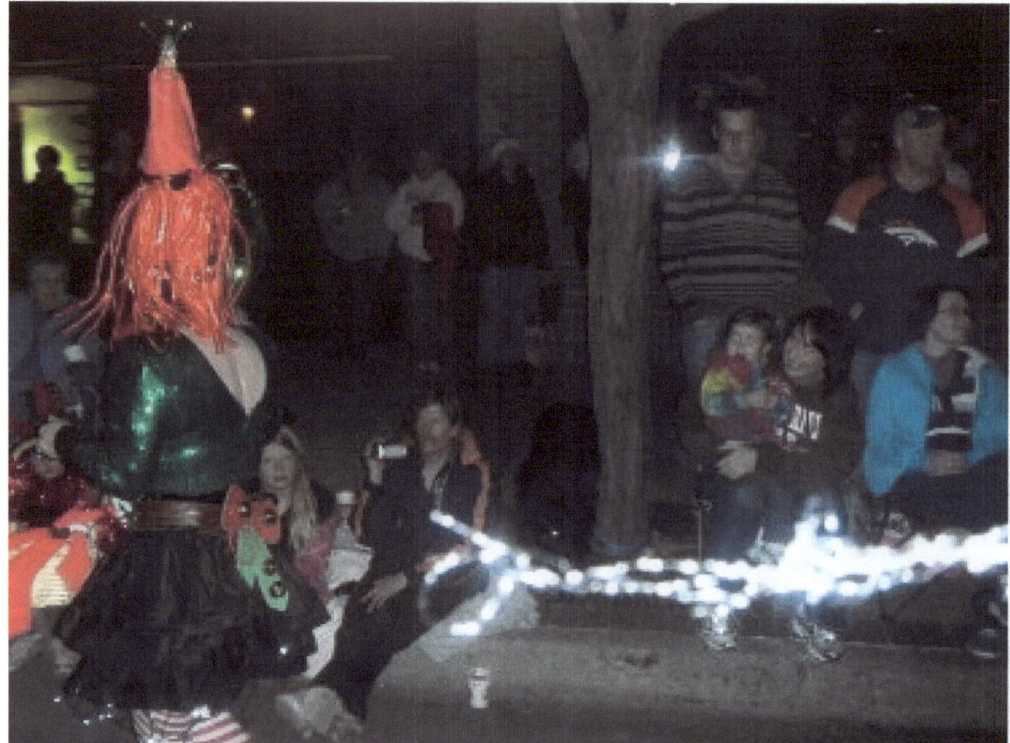

I appear here dancing during the Festival of Lights Parade, 2012, in Colorado Springs, CO. There appears to be a trail of light beings chasing me. My friend Jose took this amazing picture and there was nothing we could see behind me at the time with our naked eyes. Cameras seem to see things our eyes cannot (because they are moving so fast) and capture stopped motion as shown here.

My friend Jose caught this interesting shot of orbs bouncing around while traveling fast. This was taken during the Festival of Lights Parade, Colorado Springs, 2012.

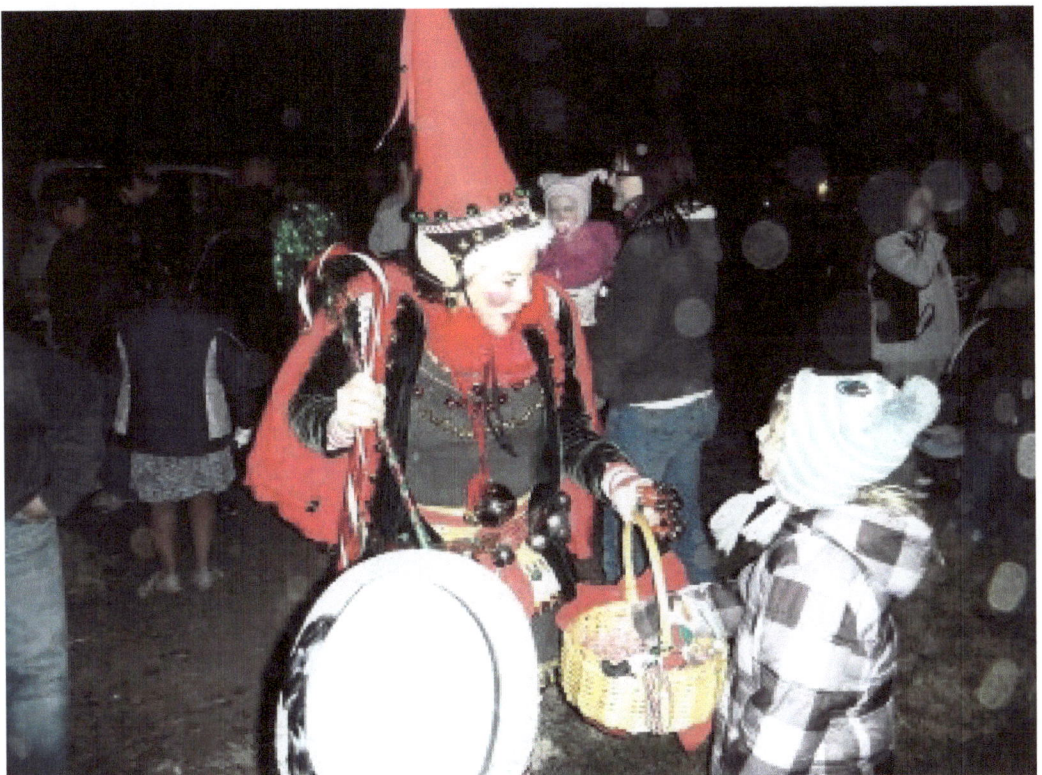

The Christmas Tree Lighting Ceremony in my hometown of Fountain, Colorado Nov. 2012 was one of the first times the rectangular shaped light beings showed up. They appear to be curving upwards on the right of this picture. In the infrared footage we shot during this event we captured moving swarms of light beings on video. Light beings show up during joyful celebrations as shown here!

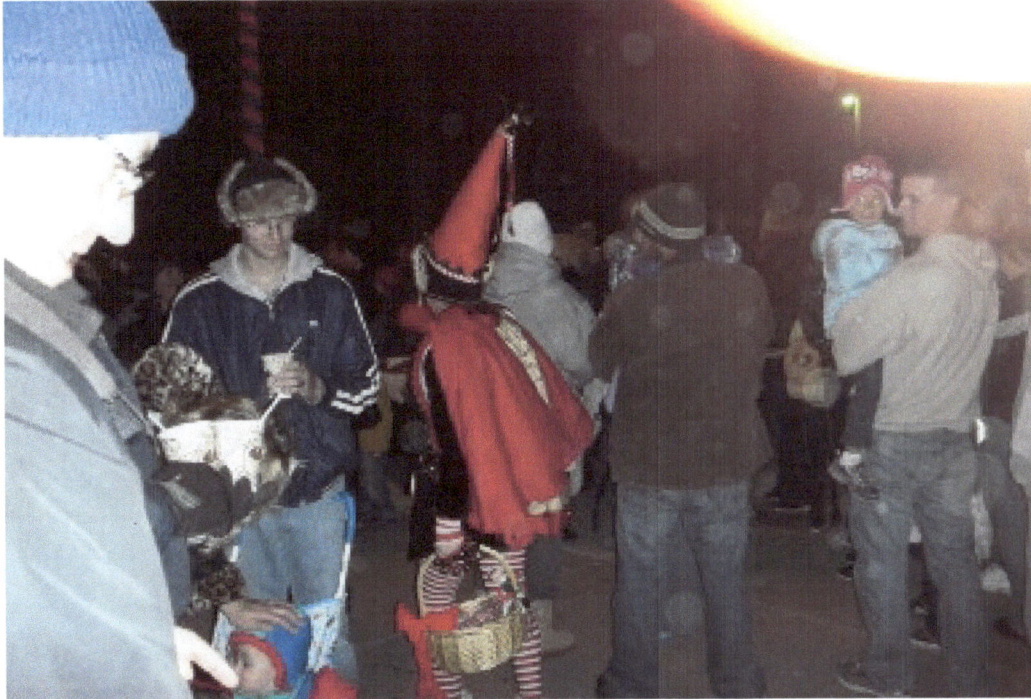

My friend Brett Leal shown here on the left took the infrared video at this event. He captured amazing moving light beings on camera! The orbs shine bright!

Orbs and elves! What a great combination...Here I am at the Tree Lighting Ceremony in Fountain, CO 2012 with crowds of people and something else. What are they? I am not sure, but I do not think they are harmful in any way, shape or form.

This picture was taken by my friend Patrica from the Fountain Valley News during the tree lighting ceremony in Fountain, Colorado. It is the best picture of a bright red orb I've ever seen.

The light beings in this shot appear to be circling on the right. This picture Jose took right before the 2012 Festival of Lights Parade, Colorado Springs.

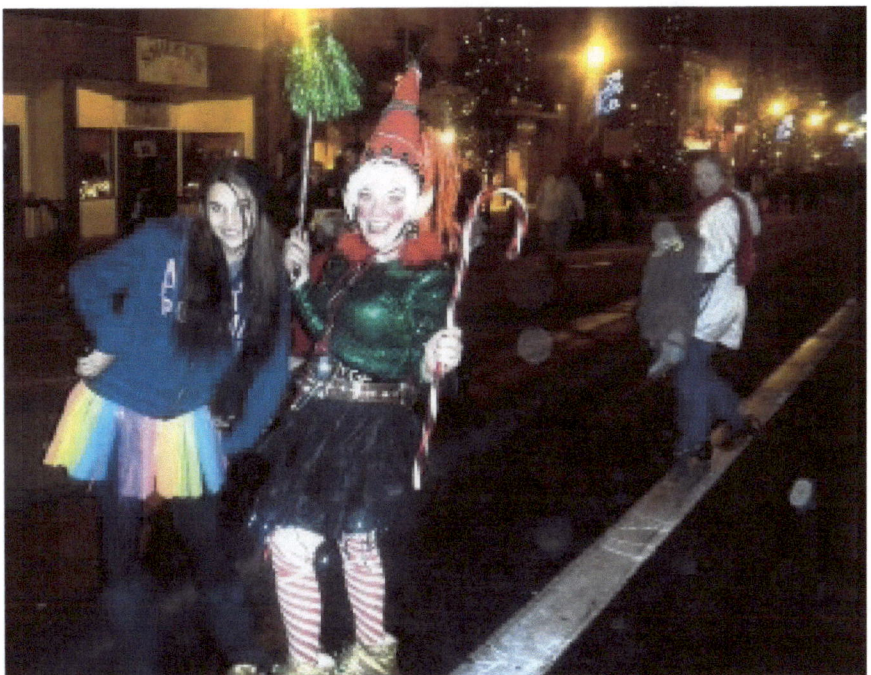

Right after the 2012 Festival of Lights Parade in Colorado Springs. The light beings continued to celebrate with me even after the parade. Thanks, Jose, for taking this shot!

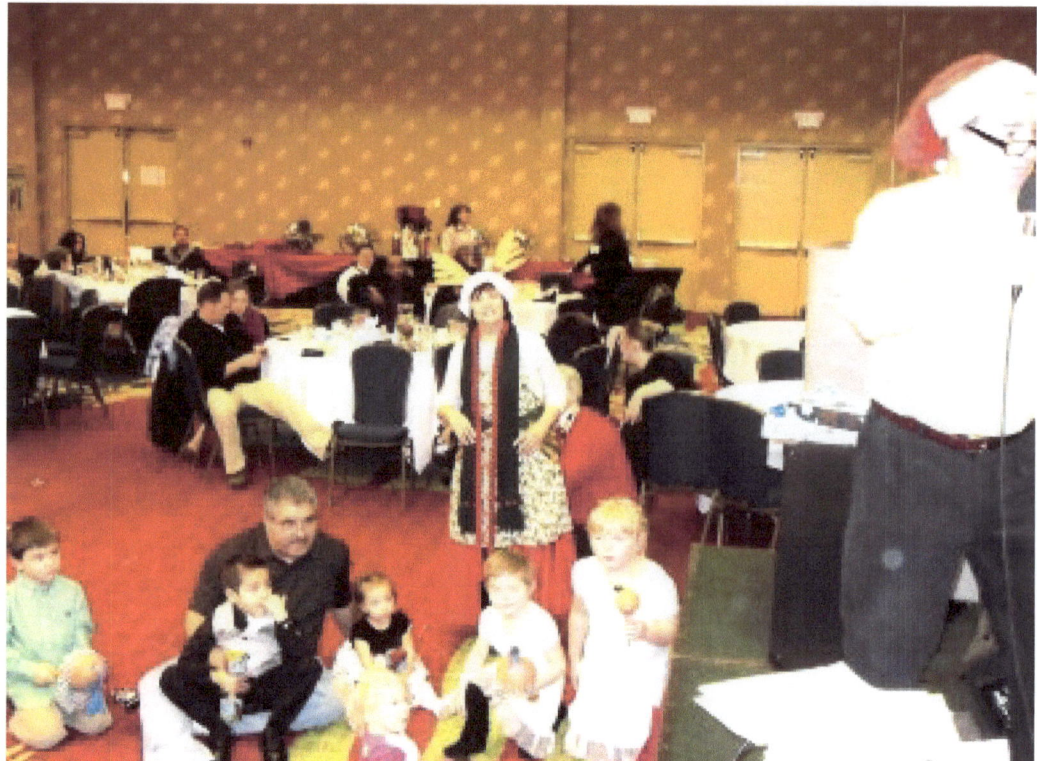

Several orbs show up to help celebrate at the Crown Plaza, 2012. There's a clear orb on Steve Shapiro's pants on stage. His wife Sheila appears in festive antlers. Orbs show up more often at times of joyful celebration.

Peace on earth! Orbs celebrate at Unity In The Rockies during a holiday women's potluck 2012 where I volunteered as Jingles, the happy elf.

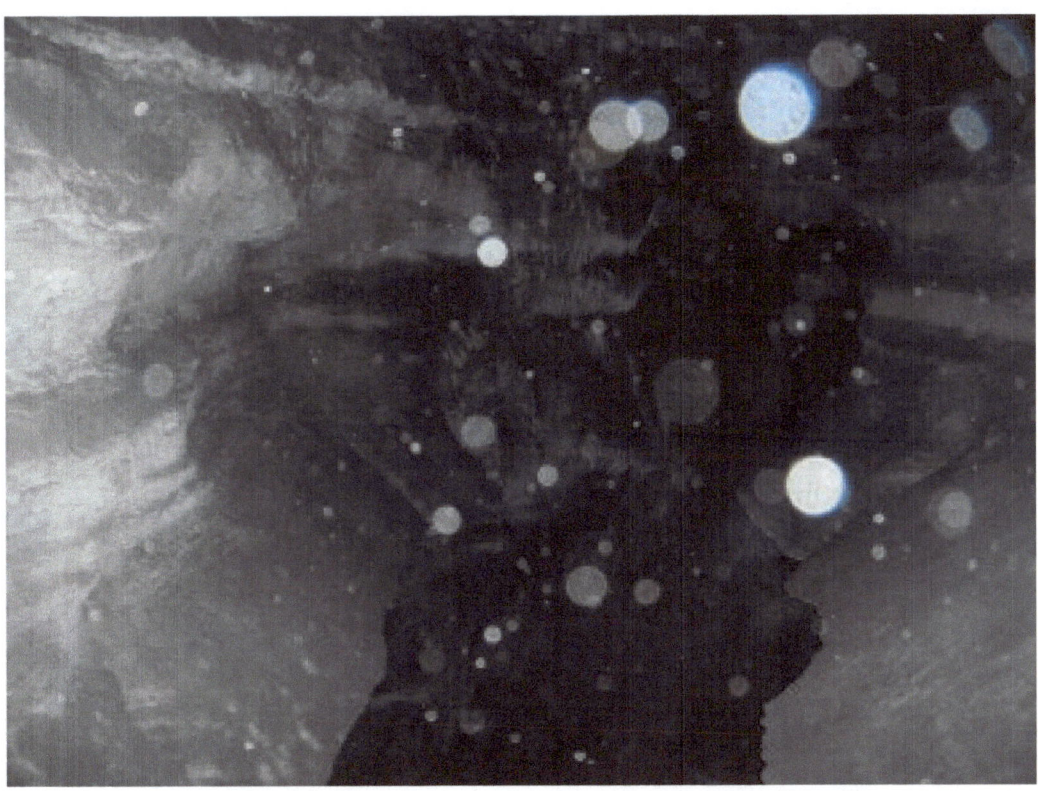

Orbs show themselves clearly inside this cavern within a cave. It appears orbs like it here!

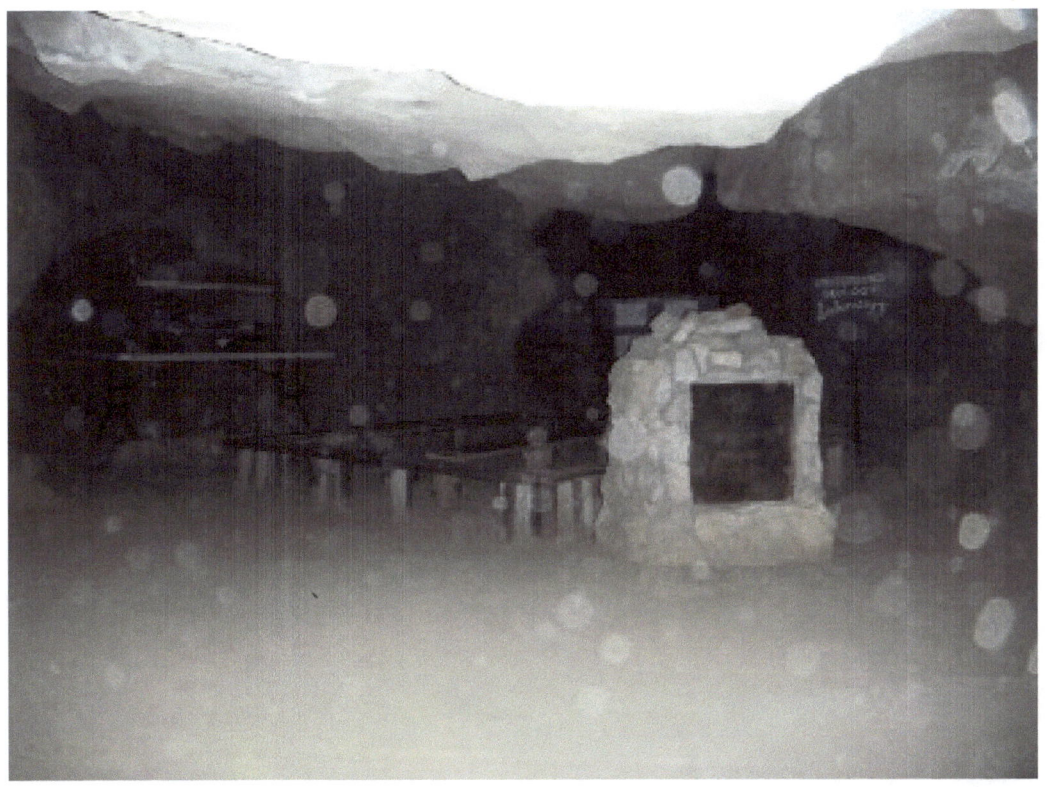

Orbs and light beings appear at this underground geology classroom inside the Cave of the Winds, CO, 2013.

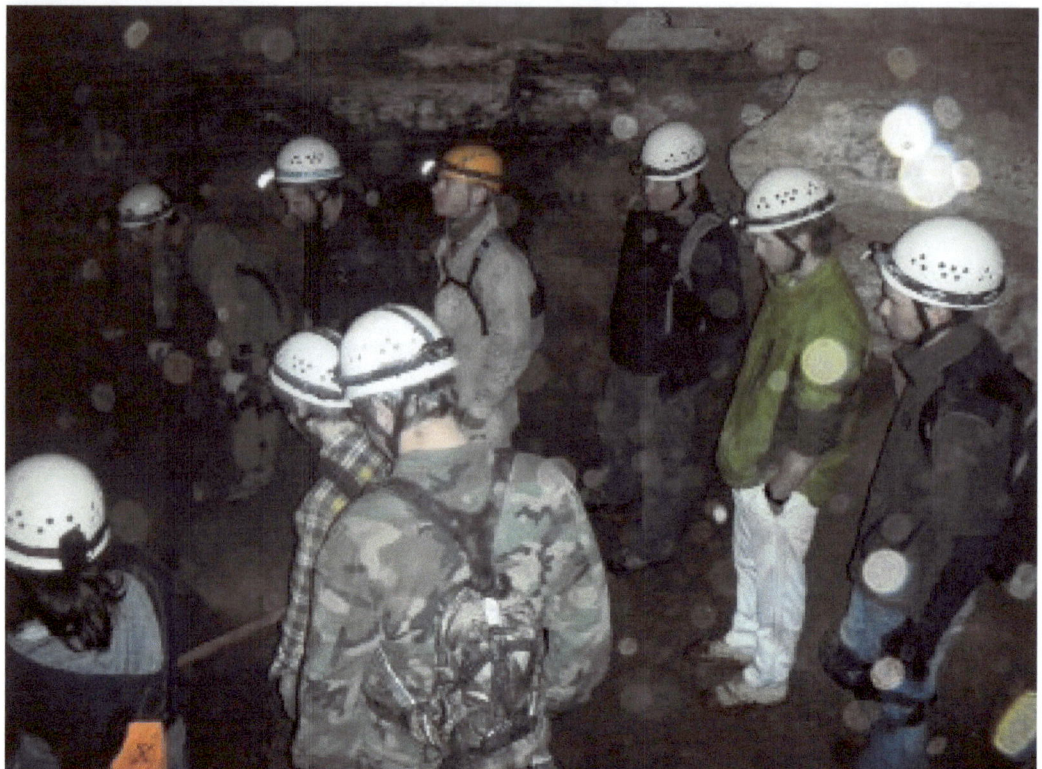

The intensity of the orbs shown here on the right is spectacular and the odd shaped light in the bottom right corner of the picture Is different.

My caving instructor, Todd Warren, shown here inside the lower levels of Cave of the Winds, Colorado with swarming orbs. He is unlocking an entrance to caves rarely available to the public he led us through.

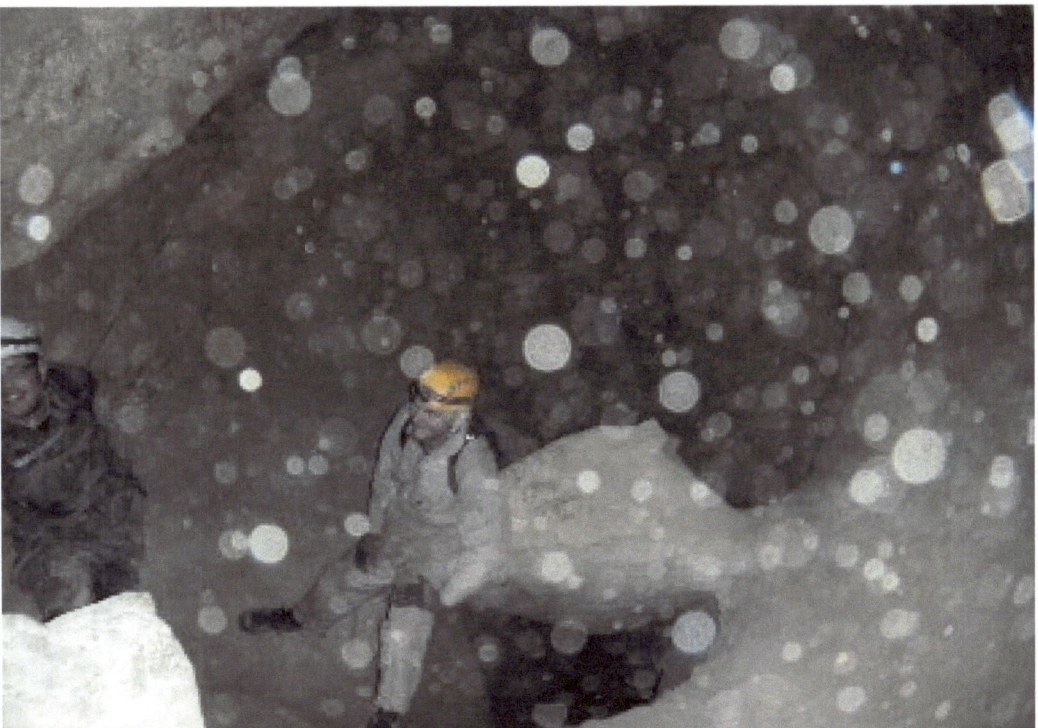

This is an amazing picture of orbs and light beings in a cave near Manitou Springs, Colorado, 2/17/13. Every picture I took inside the cave during this expedition contained orbs. These are the most colorful and varied obs I've ever photographed and I give the credit to them for showing up so clearly. The variety of shape, color, size and intensity clearly proves these are not simply dust particles. These two pictures were taken within seconds or each other and illustrate orb movement.

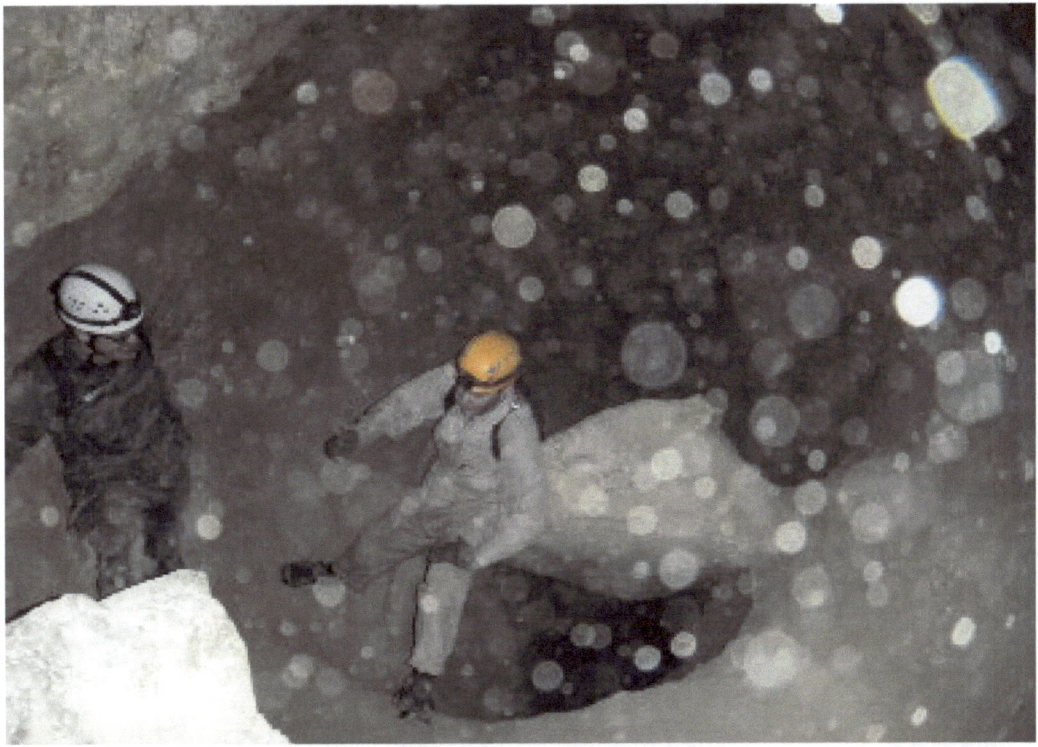

These multicolored interdimentional light beings appear to be moving in a circular rotation at the right of this picture. The pink orb is of interest, as are the brighter ones and the rectangular shaped anomaly shown at the upper right.

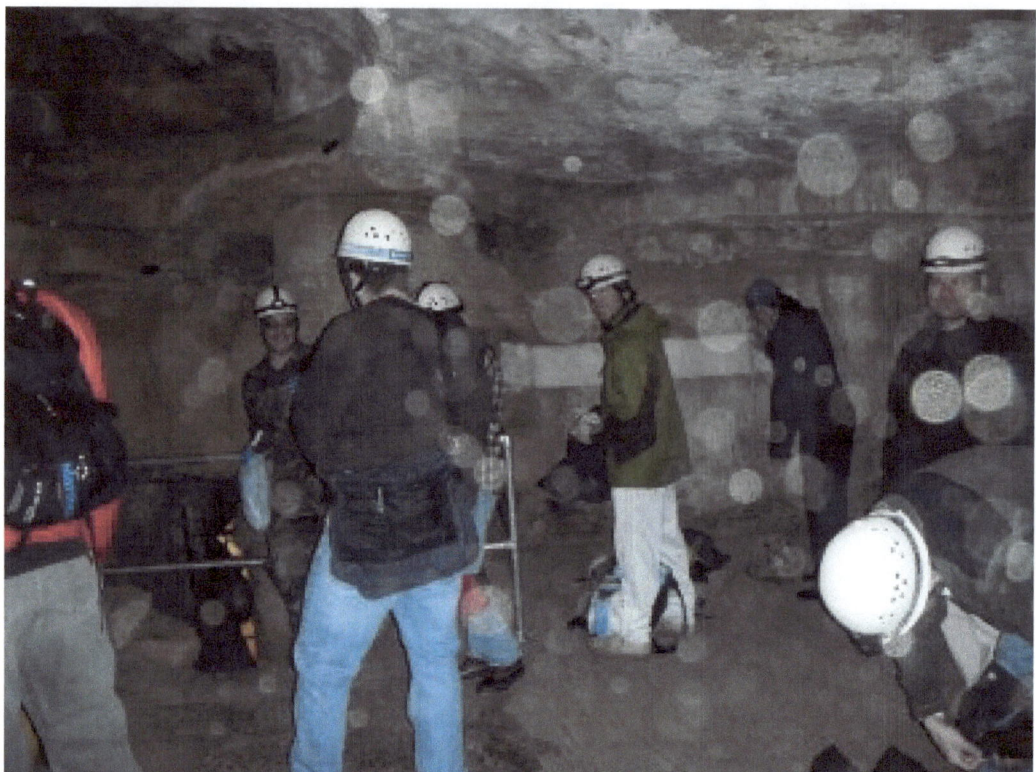

In Cave of the Winds 2 5 13 near Manitou Springs, CO with loads of orbs during a caving expedition! Simply amazing!

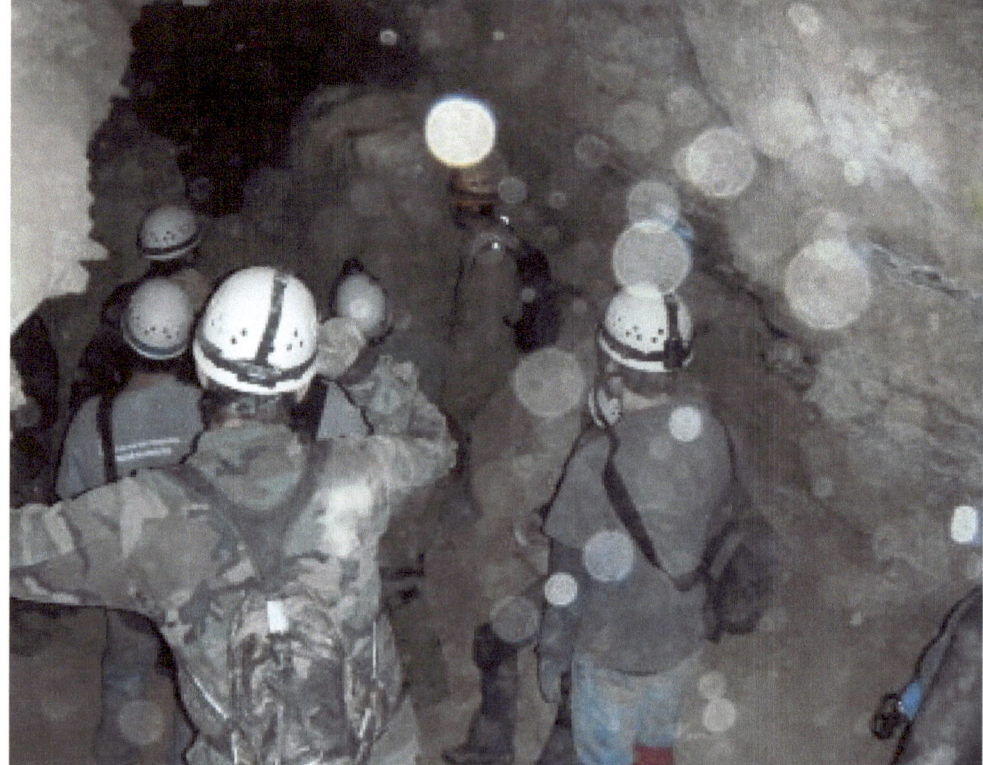

Exploring deep underground with my Pikes Peak Community College caving class. Here seen joined by countless curious light beings of different shapes, sizes and levels of brightness.

A bright white Orb shown clearly moving upwards. I took over 300 pictures during this hike and this was the only one that had an orb in it. Summer 2012. I think it's interesting that my classmates didn't particularly like me and their negative energy probably contributed to the lack of orbs in my pictures from this trip. It would not surprise me because I firmly believe they respond to energy and are communicating with us by showing up (or not...like during this particular expedition).

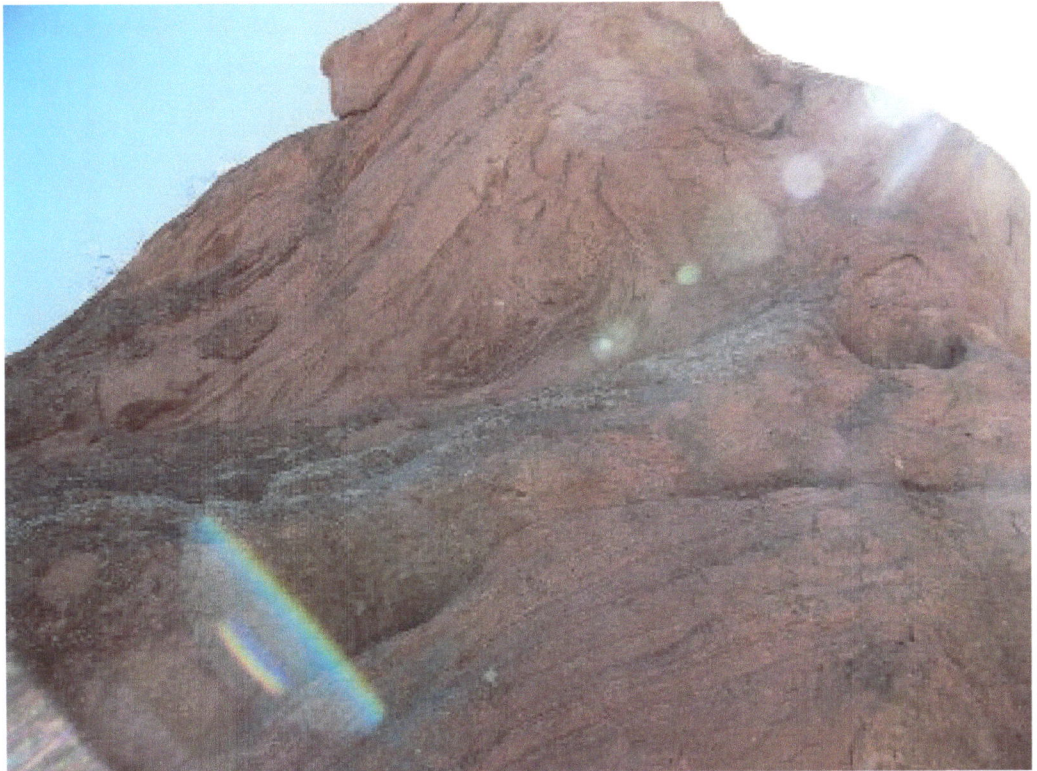

Awesome shot of a rainbow light being which appeared during a class hike, Fall 2012. Taken in an area I call Garden of the Goddesses near Old Colorado City.

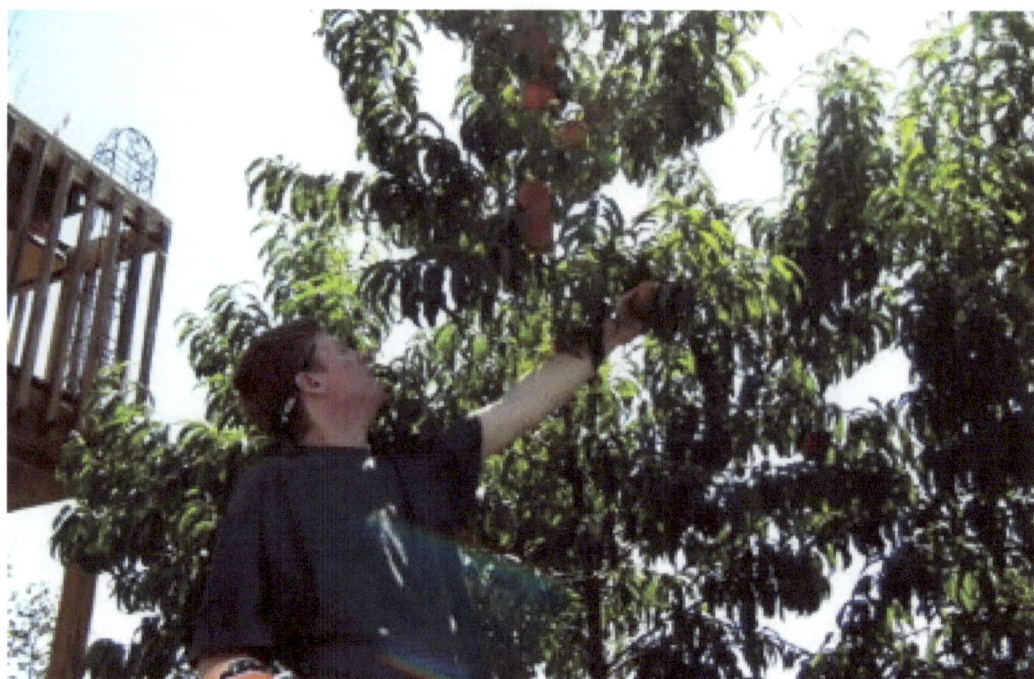

This picture is another example of a rainbow light being captured with a digital camera. The picture is of my son picking peaches off a tree in my mom's backyard in Colorado.

Amazing energy shows up in this picture in the form of rainbow light beings and an orb on the tree trunk at the bottom right that appears to have a face inside it.

This rainbow light being shined bright near a cliff in Manitou Springs, Colorado, 2012.

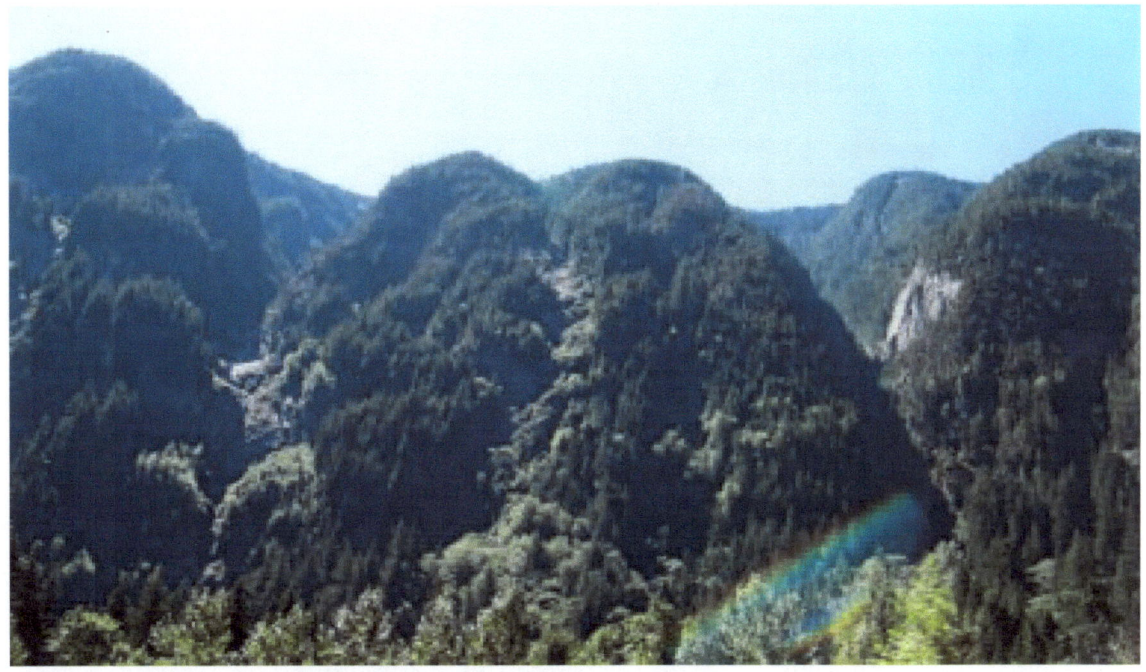
Rainbow Light Being – This picture shows an example of a "rainbow light being" I captured during a trip to Canada.

A rainbow light being showed up in this shot taken on a hike with my PPCC Outdoor Wilderness Survival Class Fall Semester, 2012.

A rainbow light being appears here over the forest during a hike to Horse Thief Falls, Colorado, Fall 2012.

Lots of energy shows up in this photo taken during a day hike near Garden of the Gods, Colorado. The neon multicolored light rod intrigues me at the upper left of this picture.

There appears to be a faint rainbow light being on the right of this shot and a faint hexagonally shaped light being in the bottom right hand corner. I hate when I see two toned chemtrails in the sky like the one that runs through the center of this picture. There is particulate matter being added to our atmosphere and I think the secrecy surrounding it needs to stop. Are chemtrails adding toxins to our atmosphere?

A strange purple light appeared in this shot I took of disturbing chemtrails over Colorado Springs, CO fall 2012.

Interesting colored lights appear in this shot taken during a hike with my survival classmates, summer 2012. I find the intense purple shown here strange.

Taken in Garden of the Goddesses. I actually saw this orb without my camera before I took this shot.

This shot was taken during a hike near Colorado Springs and contains interesting energy.

Strange light trails shown here near my RV parked by Briarhurst Manor in Manitou Springs for a paranormal themed Halloween party 2011. Some people think this is a shot of my hair, but it was pulled back in a ponytail at the time.

This is a black and white photo I scanned in from the early 1960s. I'm shown here in Alaska during a ski race award ceremony. The original picture was taken by a US Air Force photographer. The "star like" orbs that are shown in the picture make me wonder if they have been around me my entire life.

The orb at the upper left corner of this picture appears to be in motion and moving toward the upper left. Ths photograph was an old black and white from the early 1960s. When I scanned it in and adusted the lighting the colors showed up in the "star like" orbs.

The "star like" orb above is seen here enlarged and lighting enhanced. It is interesting that so much color appears because the original photo was a black and white produced by a US Air Force photographer.

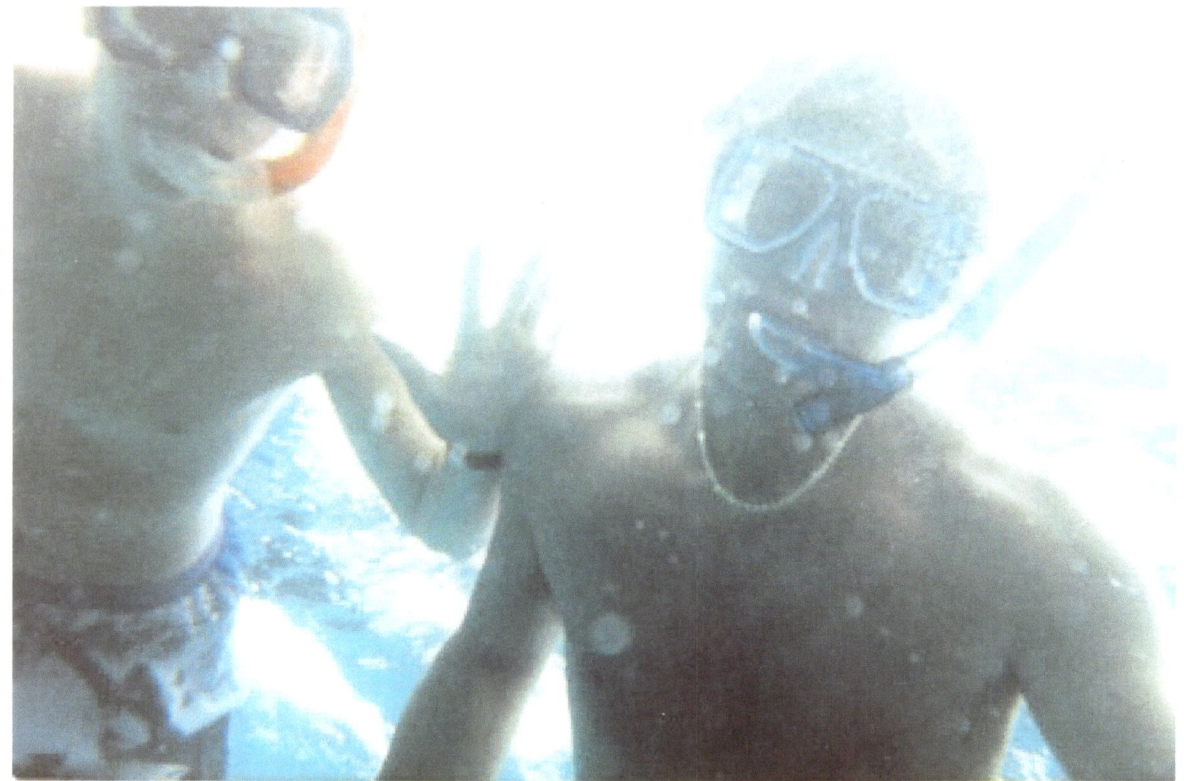

These two underwater photographs show orbs. These aren't bubbles or dust on the camera lense. I took these shots in 1988 in Hawaii.

If you compare these two underwater pictures, you'll notice that the orbs have moved and changed size between the two shots. I find the orb in front the face to the left most interesting because it is so clearly visible.

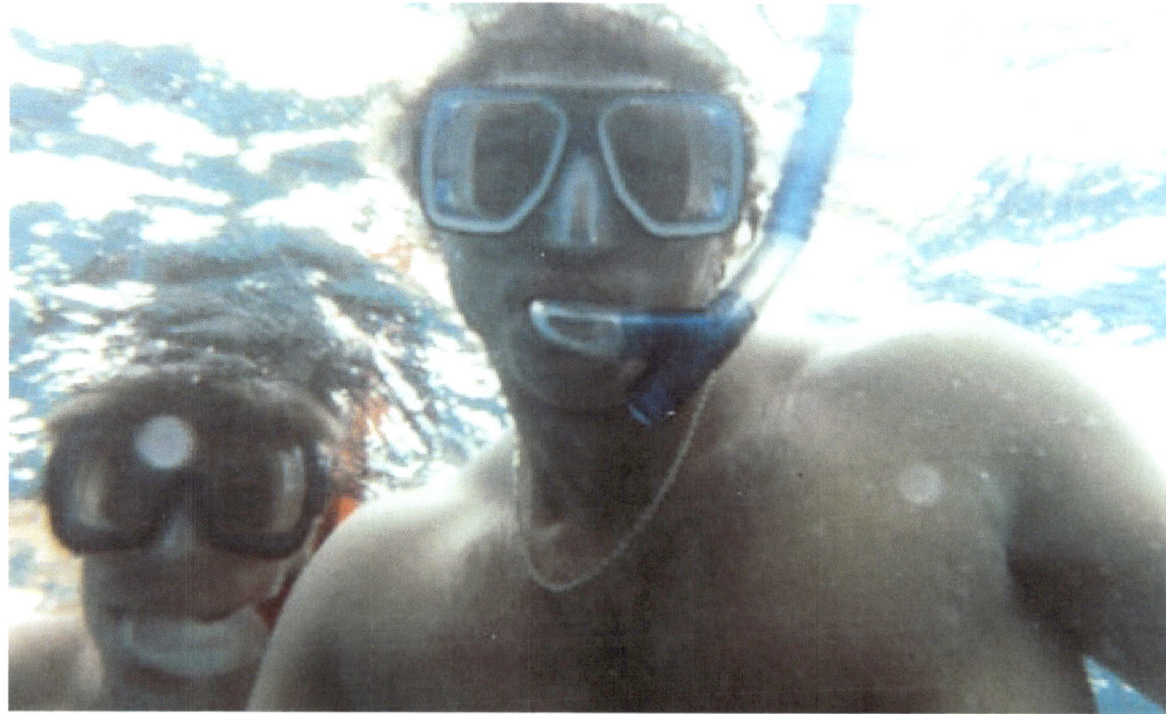

Me in 1961 at one year old with an angel on my shoulder.

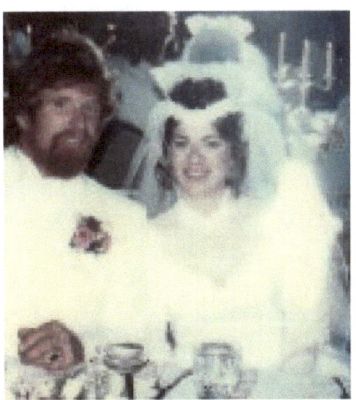

My wedding day, 1988, with an angel on my shoulder. This picture was taken by a friend using a Polaroid instant camera.

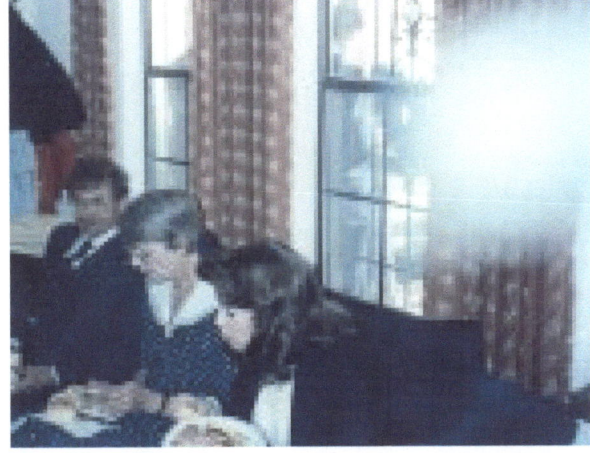

Final Family Portrait – My sister Ginny appears in this picture taken at her wake. I believe the energy or the light in the upper right corner represents her life force energy. I consider this our final family portrait because my whole family is together in it for the last time. My mom, dad and me are on the couch, my brother can be seen through the window and my sister appears as a "light being."

I am proud to serve as Communications Coordinator for UFO Institute International. Our logo is shown here:

www.ingramcontent.com/pod-product-compliance
Lightning Source LLC
Chambersburg PA
CBHW050755180526
45159CB00003B/1474